# A Cosmology of Civilization.

## A Traveling Art Show.

### By Shaharee Vyaas

For Dates and venues check the website.

www.maharajagar.com

**BOSTOEN**
**COPELAND & DAY Ltd.**
**2022**

Publishers: Bostoen, Copeland and Day ltd.
Third paperback edition
**ISBN:** 978-1-7377832-5-1

Cover design; The Clock Ticks by Shaharee Vyaas (2021).

# Introduction

This art show is a multidisciplinary project bringing together music, visual arts, literature, and science, centering them around a vision that has been developed in the manifest "The All is an Egg". The manifest is mainly an adjusted continuation of a vision Salvador Dali laid out in his Mystical Manifesto, that was a hybrid combination of nuclear physics and Catholic doctrine.

"The All is an Egg" is an essay that rests upon an attempt to offer a unifying metaphysical frame for the fragmented human knowledge. The concept is founded upon the idea of how the cyclical nature of a multitude of phenomena mirrors circulatory biological patterns. Connecting art, science, and religion, with the metaphor of the egg foisted onto it, is a transformative work, and a profound invitation to reflect.

*Print version ISBN 9781737783213 (IngramSpark), Kindle version ASIN B08BC3PD2H*

From there an artistic approach emerged, inspired by Frank Zappa's Project/Object concept for his work in various mediums. Each of the displayed projects (in whatever realm) are part of a larger object, that is defined as mystic cyclical synthetism. As such, the art show is multifaceted in its effort to bring forward a new perspective upon the nature and significance of human civilization.

This exposition does not have the ambition to be overwhelming original, but often limits itself to recycle existing ideas and themes in a coherent contemporary context. This can be illustrated by having a close look at the center piece of the exposition, a painting named after the theme that inspired this art show (A Cosmology of Civilization). It restyles much of the themes and subjects that have been developed by Salvador Dali in some of his lesser-known creations.

Most of the visual works rest between figuration and abstraction, coherence and disintegration, and organic and technological forms. They combine dream-like imagery to create surreal, liminal landscapes, trying to explore the affinity between the scientific and the artistic praxis. Very often they contain autobiographical elements that illustrate the artistically becoming of this exposition.

The theme of the opera that forms part of this project, revolves around a comparison between the cyclic nature of human civilization and that of our solar system. The music is derived from a sonorization of the electromagnetic waves emitted by the main celestial bodies that form our solar system. These chaotic sounds were then processed through a synclavier in order to produce some melodies that make sense to the human ear. In these

compositions, every sound has a value, and every action is part of the universal diapason, a colossal vibration that makes energy rather than reflecting it.

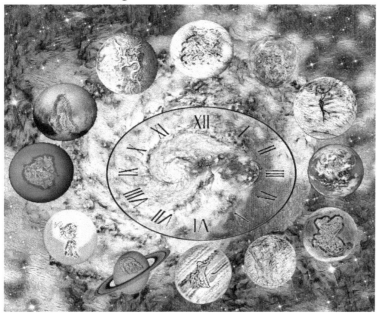

*A Cosmology of Civilization. Acrylic on canvas 100 x 80 cm by Shaharee Vyaas (2021)*

The literary facet of this art project wants to illustrate the multicultural aspect of civilization as a phenomenon by placing the tale of Mahabharata in a more contemporary context.

I had to conclude that no artist is an island, and that most artists just pick up a thread where other artists had to drop it. It is humbling to consider that most of what we do, has very often already been done before, and that our proud "inspirations" are just updated art history.

## The Becoming of an Artist.

The modern bohemian artists come across as Gypsies (which in fact was the original meaning of the word 'bohemian'), drifters or actors in a play featuring fools, visionaries or madmen, beings seemingly possessed, like them, by inspiration. In the next paintings I will try to illustrate what I consider to be the essential elements that made me turn to art to express my thoughts.

Welcome

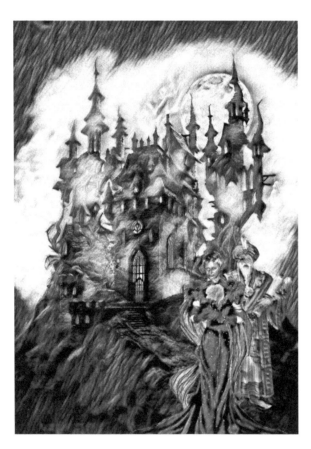

*The Lady in Red and Her Cryptomathician. Acrylic on canvas (2016)*

Last Supper on Utila.

*Last Supper on Utila. Acrylic on canvas 40 x 30' by Shaharee Vyaas.*

This painting stands at the cradle of my becoming as an artist. It is inspired by a painting of Dali (The Last Supper) and contains all the main actors that have got a heavy influence upon the way I developed my personal style and philosophy.  In the center figures Leonardo da Vinci, which I consider one of the last universal minds that embodied both the analytical approach of the scientist as the synthesizing method of the artist. He is surrounded by Salvador Dali, Marie Curie, James Joyce on his left, and by Ada Lovelace, Lao Tzu and Valentin-Yves Mudimbe on his right. In the foreground play Albert Einstein and Frank Zappa a duet. It is painted upon the background of the Island of Utila, a Caribbean Island that is part of the Bay Islands, an archipelago that belongs to the republic of Honduras. This island functioned as a catalyst that facilitated my mental distillation process.

11

"Pilgrimage to the House of Wisdom" is a painting that illustrates a story of self-discovery in the tradition of Vedic disclosure that, in probing the human heart and mind, reaches into the recesses of the Universe that is revealed within. It is also a contemporary contribution to a continuing disclosure in which voices from science, philosophy, literature, and the visual arts converge and give articulation to the most anguished questions and the most freely imagined hopes of humankind.

Pilgrimage to the House of Wisdom. Acrylic on canvas 30 x 20 cm by Shaharee Vyaas

## Passion or Obsession?

Obsession. Acrylic on camvas 30 x 40 cm by Shaharee Vyaas.

The Cambridge dictionary defines the two words as follow:
1. **A Passion** for something: an extreme interest in or wish for doing something.

2. **An Obsession**: something or someone that you think about all the time.
While a passion is "extreme behavior" it lacks the indefinite time connotation. We all have passions but how many times have we given up on a passion after a while?

Obsessions stay "all the time" and are very often linked to psychologically unhealthy attitudes such as, fanaticism, father complex, idée fixe (psychology), psychical inertia, regression (psychology) or substance dependence.

In such a context, people may be reluctant to describe themselves as an obsessive. Nevertheless, when you're having an idea that sticks to you wherever you go, whatever happens to you and can't refrain yourself from thinking and acting on it, you're obsessed.

My partner calls me a self- proclaimed artist. Are there any other? She refuses to decorate our main living spaces with my artistic productions (they're banned to a barely used sleeping room), finds in general my art "difficult to access" and that I'm having delusional thoughts about my own geniality.

I also suffer from insomnia: very often I wake up in the middle of the night to work. I need extensive prodding to be lured out of my studio to attend some social (mostly artistic) event. Lately I'm also getting exasperated about the amount of time a "successful" artist has to spend on self-promotion, so I gave it up. Away with the marketing gurus who talk about finding my "niche". If there exists a "niche" for my projects, it will have to find me. And as far I'm concerned: the world is my oyster (the marketeers probably hate that phrase).

People call me also crazy but it's also extremely easy to understand why and ignore it. I can turn into a real insufferable prick when circumstances prohibit me for some extended period from working on my own projects. How long it may take, how difficult it may be, how high the probability of failure is; it all doesn't matter to me when it's about my artistic projects.

Passion made me start, obsession keeps me continuing. Even when the world doesn't seem to bother too much about my creations, they bother to me. They give shape to my reality. To be or not to be.

## The Cybernaut.

The Cybernaut. Acrylic on canvas

This term is used to describe a person (an "electronic astronaut") who makes extensive use of the internet, specifically in terms of the exploration of cyberspace. The new information technology offers every creative mind the tools to experiment with images, music and texts without having first to wrestle three years through some art school, music conservatorium or creative writing degree. Not only the distribution of art has been democratized, but also its creative process. Of course, it still takes a creative mind to do something innovative with those new tools. Fact is that you do not have to spend three to five years of your life anymore to acquire some basic skills that each art form requires. You have computer programs who can do the mind-numbing work for you. That is what for they were created. Nowadays the artist can express his creative drive by using computer generated music, images and texts. What remains however is that it still takes some perseverance, intellect, and discipline to create something artistically meaningful.

## The Vampire

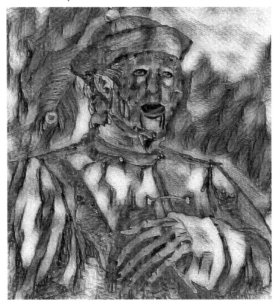

The Vampire. Acrylic on canvas 30´x 30' by Shaharee Vyaas.

Let us face it: most artists are rippers. James Joyce ripped Odysseus by Homer for his novel Ulysses, Dali ripped Da Vinci for his painting The Last Supper, John Williams ripped The Planets by Gustav Holst for the soundtracks of Star Wars...I ripped Dali for my painting a Cosmology of Civilization, the NASA sonorization of the electromagnetic waves emitted by the planets of the solar system to compose my opera, the concept of Joyce's Ulysses and the story line of Mahabharata for my own novel The Maharajagar, ... the list is almost endless. Hence every artist is in a way vampirizing the works of other people.

I have no problem with people finding inspiration in other people's work in order to create something new. I know, there is a thin line between plagiarism and ripping, but the essence is that when someone comes up with an original idea, you cannot prevent people from taking inspiration into it. It is a long and difficult discussion, and not one that I want to start here.

## Inspiration

Inspiration. Acrylic on canvas 20 x 55 cm by Shaharee Vyaas.

On top of this painting you find the image of my companion, who's also my guiding genius and the source of my artistic inspiration. At the bottom you see my face peeking out between the bushes while in the middle hovers a figurine that symbolizes my mind , hovering between the visionary and real world.

The word "Inspiration" has an unusual history in that its figurative sense appears to predate its literal one. It comes from the Latin inspiratus (the past participle of inspirare, "to breathe into, inspire") and in English has had the meaning "the drawing of air into the lungs" since the middle of the 16th century. This breathing sense is still in common use among doctors, as is expiration ("the act or process of releasing air from the lungs"). However, before inspiration was used to refer to breath it had a distinctly theological meaning in English, referring to a divine influence upon a person, from a divine entity, this sense dates back to the early 14th century. The sense of inspiration often found today ("someone or something that inspires") is considerably newer than either of these two senses, dating from the 19th century.

The Final Solution.

*The Final Solution. Acrylic on Canvas 30 x 40 ´ by Shaharee Vyaas.*

This painting is grafted upon the background of the crematoria of Auschwitz. Behind the entrance gate of the extermination camp you can see Jesus who carries his cross towards the crematoria while the sign above the entrance gate reads "Arbeit macht Frei" (work sets you free).

The leaders of Nazi Germany, a modern, educated society, aimed to destroy millions of men, women, and children because of their Jewish identity.

Sadly enough, the holocaust didn't end pogroms and genocides, since they continue to happen all over the world.

Understanding this process may help us to better understand the conditions under which mass violence is possible and to take steps to prevent such conditions from developing.

## Galactic Pilgrims

I've encountered this lore for the first time in the Star Wars series where Jedha, a small desert moon frosted by a permanent winter, was home to one of the first civilizations to explore the nature of the Force. At one time a world important to the Jedi Order, Jedha served as a holy site for pilgrims from across the galaxy who sought spiritual guidance.

In a game created by LegendaryCollector, "Galactic Pilgrim" is an A.I. machine and a member of the Interspecies Collaboration. The Interspecies Collaboration was constructed by humans and machines who thought that working together instead of against each other was the way into the future. The "Galactic Pilgrim" is on the lookout for new habitable planets in her custom-built spaceship "Seeker" that is equipped with a fully autonomous explorer drone.

There exists also a HipHop group called Galactic Pilgrims who made an album called The Dark Side (https://soundcloud.com/thabenjaofficial/galactic-pilgrims-dark-side) and launched in 2017 a project called Artz &nd Craftz (https://soundcloud.com/thabenjaofficial/galactic-pilgrims-artz-nd-craftz). I have no knowledge of more recent projects.

Galactic Pilgrim exists also into the form of an album of Christian inspired poetry by Daniel Orsini that wants to explore key concepts from Jungian psychology and the new physics. In this bundle the author examines the spiritual as well as the psychological effects of being a Christian, trying to reconcile them with an amalgam of diverse yet related influences.

The theme also relates to my own project " A Cosmology of Civilization" since it incites people to have a look upon human civilization from a broader perspective.

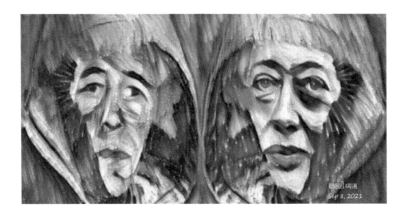

*Galactic Pilgrims. Acrylic on Canvas 12 x 24' by Shaharee Vyaas (2021)*

## The Valkyrie in Modern Art

Valkyrie, also spelled Walkyrie, were a group of maidens who served the god Odin and were sent by him to the battlefields to choose the slain who were worthy of a place in Valhalla, a realm of the Norse afterlife that Vikings aspired in life to enter upon their death.

And then you have the legendary matriarchate of the Amazonas.

The eighth-century B.C. poet Homer was the first to mention the existence of the Amazonas. In the Iliad—which is set 500 years earlier, during the Bronze or Heroic Age—Homer referred to them somewhat cursorily as Amazonas *antianeirai*, an ambiguous term that has resulted in many different translations, from "antagonistic to men" to "the equal of men."

In 1861 a Swiss law professor and classical scholar, named Johann Jakob Bachofen, published his radical thesis that the Amazonas were not a myth but a fact. It comes as no surprise that the composer Richard Wagner was enthralled by Bachofen's writings. Brünnhilde and her fellow Valkyries could be easily mistaken for flying Amazons.

Most anthropologists hold that there are no known societies that are unambiguously matriarchal and define modern time wannabe amazonas as an extreme, feminist wing of humanity.

In this time of a rising tide of gender equality issues, the prospect that there existed female warriors is butter upon the bread of feminist activists. Girls don´t want to be girls anymore so long as their feminine archetype lacks force, strength and power. Not

wanting to be girls, they don't want to be tender, submissive, peace-loving as good women are.

Contemporary bestselling US literature favors the female lawyer or detective as main protagonist. Writers such as Sara Paretsky, Sue Grafton, and Marcia Muller create compelling feminist protagonists to fill the role of detective. The successes and failures of these feminist detectives have then been measured against the standards created in the classic genre by Raymond Chandler, Dashiell Hammett, and James M. Cain. It is clear that feminist hard-boiled detective fiction is a genre of political protest, even better received when served with some LBTQ sauce.

Women in the modern art period have thrived in all types of mediums — prints and drawings, painting and photography, sculpture, installation art, performance art, and many more. The field of contemporary art is abundant in female visionaries who continue to challenge the norms with their constant innovations and are never afraid to express their points of views and earn their deserved canonical spots in art history.

As *Marina Abramović* put it "*The artist in a disturbed society is to give awareness of the universe, to ask the right questions, and to elevate the mind*".

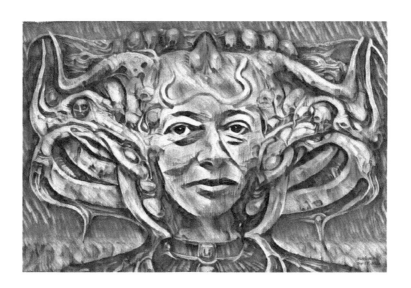

*The Valkyrie. Acrylic on canvas 40 x 60' by Shaharee Vyaas (2021)*

## Demon

Most authors who wrote theological dissertations on the subject either truly believed in the existence of infernal spirits or wrote as a philosophical guide to understanding an ancient perspective of behavior and morality in folklore and religious themes.

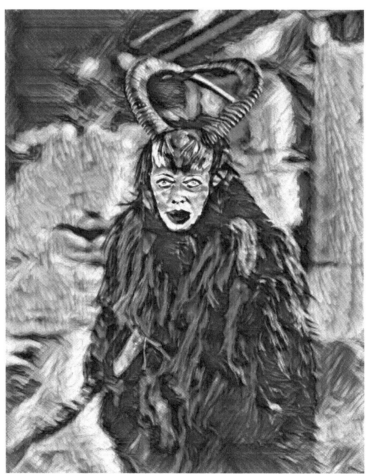

*Demon. Acrylic on canvas 40 x 60´ by Shaharee Vyaas*

I leave it in the middle if demons exist as independent beings who walk our reality but feel rather sure that most people are familiar

with the existence of some demons that they struggle with. They mostly consist of some irresistible auto-destructive drive like substance abuse, promiscuity, gambling, and many other vices that ultimately can lead to the physical and moral bankruptcy of a life.

In my opinion the true demons that walk this planet and that are not exclusively rooting into our own mental processes, are the demagogues that incite people to commit morally questionable acts while letting them believe they´re doing the right thing. You find them prominently among cult leaders, politicians, and managers of multinational corporations. Their power to disturb the moral compass of a mass of followers can sometimes astonish a thoughtful observer.

A second category consists of the people with a damaged mind. Here I´m referring to the psychopaths, sociopaths, and schizophrenic. These people have a broken moral compass and are driving other people into ruin to satisfy some alien mental disposition.

Finally, we sometimes perceive demons where there are none. Like some youngsters demonizing the older generations for all the social and cultural imperfections they perceive, or the left- and right-wing politicians mutually blaming each other for a lack of common sense (while the truth usually lays in the middle, but polarization is easier to sell to a voting public), or the eternal disputes between men and women about whom has the right perspective upon the reality (while both views have their merits and shortcomings).

I just contend myself to state that every person has different facets to their personality.

Nereid and Faerie

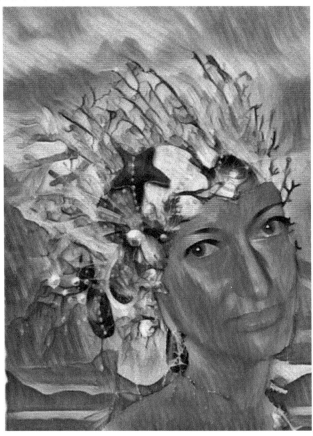

*Nereid. Acrylic on canvas 45' x 60' by Shaharee Vyaas (2016)*
These canvases complete a series of portraits that also include two previous paintings: Valkyrie and Demon. Each of the portraits illustrates a different facet of a person

Nereids are nymphs of the sea (specifically the fifty daughters of the old sea god Nereus), and usually are benevolent and playful, taking care with the fate of sailors. Although mortal, they live supernaturally long lives. usually invisible, non-human spirits that

linger in the hidden and in-between places—most often found in nature.

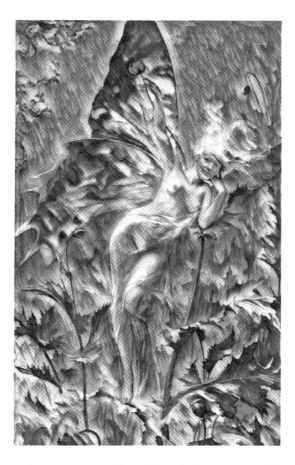

*Faerie. Acrylic on canvas 40' x 60' by Shaharee Vyaas (2016)*

Flower Fairies are nature spirits who care for flowers, plants, and trees. The evocative 'song' each Flower Fairy sings, helps convey the 'spirit' of her flower.

# The Zone.

These paintings bring together a formal investigation into color and line, with social issues pertaining to power, history, and the formation of personal and cultural identity in the globalized world.

The paintings occur in an intangible no-place: a blank terrain, an abstracted map space that I call The Zone, a metaphoric, tectonic representation of the no man's land between the Noosphere and the individual. I want to bring The Zone into time and space by connecting it to the five alchemistic elements: earth, water, air, fire, and ether.

In the globalized world most people focus on the global and too few focus on the inside. These paintings want to invite people to internalize their experiences and mapping them by reflecting about following issues;

## The Flow as the River of Knowledge.

This canvas is derived from the image of a river rapid to illustrate that The Zone can be a dangerous place for fragile minds. The Flow is a metaphysical river that meanders through The Zone and is the only way to access it. To find it, some people use hallucinogenic substances to widen their perception and might end up as addicts. Most people emerge from it as improved persons, some others with a broken mind.

The Flow. Acrylic on canvas 30' x 30' by Shaharee Vyaas.

"The Flow has its counterparts in the rivers that run through our civilizations like strings through beads, and there is hardly an age that is not associated with its own great waterway. The lands of the Middle East have dried to tinder now, but once they were fertile, fed by the fruitful Euphrates and the Tigris, from which rose flowering Sumer and Babylonia. The riches of Ancient Egypt stemmed from the Nile, which was believed to mark the

causeway between life and death, and which was twinned in the heavens by the spill of stars we now call the Milky Way. The Indus Valley, the Yellow River: these are the places where civilizations began, fed by sweet waters that in their flooding enriched the land. The art of writing was independently born in these four regions, and I do not think it a coincidence that the advent of the written word was nourished by river water." (Adapted quote from "To the River" by Olivia Laing)

Access to fresh water has replaced oil as the primary cause of global conflicts that increasingly emanate from drought-ridden, overpopulated areas of the world.

*The Earth Porcupine. Acrylic on canvas 30' x 30' by Shaharee Vyaas.*

This painting, symbolizing the Earth aspect of The Zone, emerged from the image of a porcupine. A shipwrecked boat lays at the bottom, symbolizing the way civilization made landfall. This accident incited the newly arrived humans to build a city that lies there like a war bristling porcupine.

Schopenhauer observed in Parerga and Paralipomena: "In the same way the need of society [i.e., love, friendship, companionship] drives the human porcupines together, only to be mutually repelled by the many prickly and disagreeable qualities of their nature...By this arrangement the mutual need of

31

warmth is only very moderately satisfied; but then people do not get pricked."

Porcupines evolved with the forests and are part of a system of forest replenishment. Trees damaged by porcupines provide critical habitat for dozens of other species. These trees then become part of the nutrient cycling essential to forest health, the same way a well-conceived civilization sustains its habitat. It works as a capillary tissue that ensures the constant and benevolent exchange between the environment and human society.

The Flame of Kali.

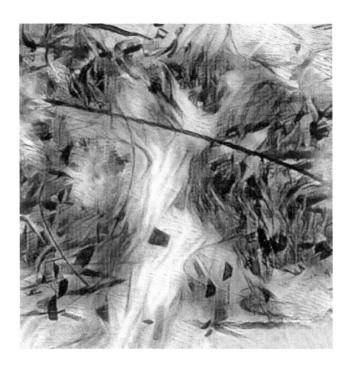

*The Flame of Kali. Acrylic on canvas 30′x 30′ by Shaharee Vyaas.* Kali dances in the fire, and is a fearsome, dark and very popular Goddess in India.  She destroys what is ready to be reborn, and in

this way she urges us to move through our own cycles of death and rebirth in attitudes, energies and our physical reality.

Fire became as integral to the ecology of ideas as to that of the Earth. It does for civilization what it does for wildlands and dwellings. It can rework human society as it does metal or clay. The place the hearth held in a home, that the prytaneum held for a city, or a vestal fire had within a culture, intellectual fire has for The Zone. With it gods were manifest, about it myths were told, through it philosophy was explored and out of it a science evolved.

There are two general metaphors in play. One is fire as disaster. Fires in built environments, municipal watersheds, and amid rare, fire-intolerant ecosystems can be disasters. But most wildland fires are not. The other metaphor is the firefight as battlefield. This is both inaccurate and damaging. If, in fact, we are at war with fire, three things will happen. We will spend lot of money, we will take a lot of casualties, and we will lose.

To paraphrase Dostoyevsky from his novel The Possessed: the fire that ultimately matters is not the fire on the roof or in the bush or in the dynamo, but the fire in the mind.

The Winds of Fate.

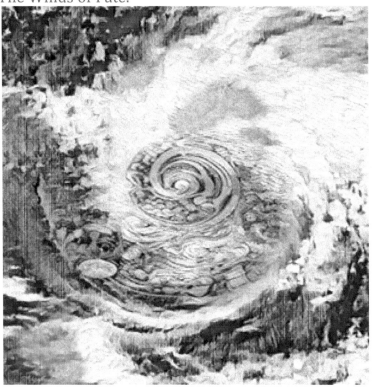

*The Winds of Fate. Acrylic on canvas 30' x 30 ' by Shaharee Vyaas.*

There is only one way to enter The Zone, but different ways to leave it. Some people must be pulled out of The Zone by concerned relatives or friends. My way out was offered by an aerial picture of the hurricane Katarina that I reworked to become this painting. Albeit it is an image that exhales a tremendous force of destruction, it also reflects the beauty of nature that seeks a new equilibrium.

One ship drives east and another drives west
With the self-same winds that blow;
  'Tis the set of the sails
  And not the gales

That tells them the way to go.

Like the winds of the sea are the winds of fate
As we voyage along through life;
  'Tis the set of the soul
  That decides its goal
And not the calm or the strife.

World Voices. by Ella Wheeler Wilcox
New York : Hearst's International Library Company, 1916

## The Ethereal Sombrero.

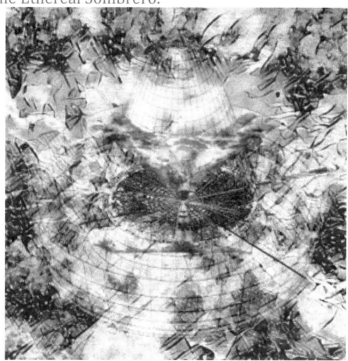

*The Ethereal Sombrero. Acrylic on canvas 30' x 30' by Shaharee Vyaas.*

The Ethereal Sombrero is the keystone of this experiment that connects The Zone to the five alchemist elements earth, water, air, fire, and ether.

The background of the painting symbolizes the chaotic nature of the universe and, by extrapolation, human society, the background against which the process of civilization takes place. The sombrero is a metaphor that scientists use to describe the Higgs Field. The Higgs field is a field of energy that is thought to exist in every region of the universe. The field is accompanied by a fundamental particle known as the Higgs boson, which is used by the field to continuously interact with all other particles. The Higgs Field's sociological counterpart is called the noosphere, a postulated sphere or stage of evolutionary development dominated by consciousness, the mind, and interpersonal relationships.

In the middle of the sombrero, symbolizing the Higgs Field, is a schematic representation of a Higgs particle gaining mass. Without the Higgs field, there wouldn't be any reality or even gravity because there wouldn't be any mass. The evolutionary analogy is that without a noosphere, there can't be any civilization. The particle in the middle of the circle symbolizes civilization accelerating through the noosphere.

Both processes play against a cosmically horizon that emanates the laws of nature (symbolized by the hands) that govern all cosmological processes. Just like the cosmos, the process of human civilization is governed by its own imperatives. The envelope of civilization has since the beginning of humanity been jumping around the globe, depending upon what culture and environment was best suiting its needs.

# A Cosmology of Civilization: visual works

This collection relates to the alchemy of chaos. It is an experience of the birth of new insights and part of a journey that will challenge you, move you, and ignite you.

It represents what you are searching for and what you're running from, all in one. It is an unconventional conversation, alive with the tension of multiple possibilities. The artworks relate to an ancient pursuit that is part scientific, part spiritual, and part magical, that is applied to transform something of little value into something of great value.

## The Complexity of Simplicity

*The Complexity of Simplicity. Acrylic on canvas 12' x 24' by Shaharee Vyaas .*

"Being simple is the most complicated thing nowadays." -Ramana Pemmaraju

The principle of simplicity or parsimony—broadly, is the idea that simpler explanations of observations should be preferred to more complex ones—is conventionally attributed to William of Occam, after whom it is traditionally referred to as Occam's razor. This

37

does not mean that there will be no longer difficult issues remaining.

The complexity bias is a reason why we humans lean towards complicating our lives rather than keeping things simple. When we are faced with too much information or we are in a state of confusion about something, we will naturally focus on the complexity of the issue rather than look for a simple solution.

Although simplicity and complexity are not in conflict with one another, they are indeed opposites in that they are two poles of a continuum—the more complex something seems the less simple it seems, and vice versa.

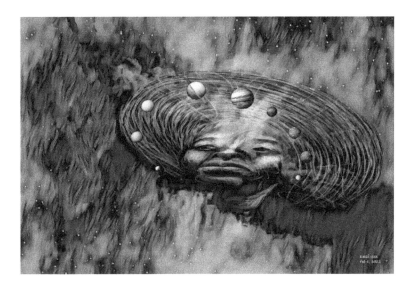

Trying to Understand (acrylic on canvas 45' x 30') is a painting that wants to invite you to approach the surrounding reality from a higher level to find its meaning and purpose, and to base your believes and actions upon those insights.

The following paragraph is a citation from "Dust Tracks on a Road", the (controversial) 1942 autobiography of the black American writer and anthropologist Zora Neale Hurston.

"Prayer seems to be a cry of weakness, and an attempt to avoid, by trickery, the rules of the game as laid down. I do not choose to admit weakness. I accept the challenge of responsibility. Life, as it is, does not frighten me, since I have made my peace with the universe as I find it, and bow to Its laws. The ever-sleepless sea in its bed, crying out "how long?" to Time; million-formed and never motionless flame; the contemplation of these two aspects alone, affords me sufficient food for ten spans of my expected lifetime.

39

It seems to me that organized creeds are collections of words around a wish. I feel no need for such. However, I would not, by word or deed, attempt to deprive another of the consolation it affords. It is simply not for me. Somebody else may have my rapturous glance at the archangels. The springing of the yellow line of the morning out of the misty deep of dawn is glory enough for me. I know that nothing is destructible; things merely change forms. When the consciousness we know as life ceases, I know that I shall still be part and parcel of the world. I was a part before the sun rolled into shape and burst forth in the glory of change. I was when the earth was hurled out from its fiery rim. I shall return with the earth to Father Sun and still exist in substance when the sun has lost its fire and disintegrated into infinity to perhaps become a part of the whirling rubble of space. Why fear? The stuff of my being is the matter, ever-changing, ever-moving, but never lost; so what need of denominations and creeds to deny myself the comfort of all my fellow men? The wide belt of the universe does not need finger-rings. I am one with the infinite and need no other assurance".

*Chased by Time. Acrylic on canvas 30' x 20' by Shaharee Vyaas*

According to theoretical physicist Carlo Rovelli, time is an illusion: our naïve perception of its flow doesn't correspond to physical reality. He posits that reality is just a complex network of events onto which we project sequences of past, present, and future. It is also possible to stop time. All you need to do is travel at light speed, which is deemed impossible by the current state of our understanding of the Universe.

Cyclical time, naturally enough, emphasizes repetition and is very much influenced by the cycles apparent in the natural world. … In many cultures, these kinds of cyclical patterns are infinitely repeatable and part of a recurring overall cycle of time. Time is cyclic. It moves on linear scale from one state to another and from the last state it recycles back. The periodicity of history is based on the repetition or recurrence of social processes.

41

The cyclic theory of the universe is a radical alternative to the standard big bang/inflationary scenario that offers a new approach by stating that our universe, and by extension our whole reality, is the product of a cyclical process. This theory states that the observable universe lies on a brane separated by a small gap along an extra dimension from a second brane. The cyclic model proposes that the big bang is a collision between branes that occurs at regular intervals. The theory is based on three underlying notions:

(1) the big bang is not the beginning of space and time, but rather a transition from an earlier phase of evolution;

(2) big bangs occurred periodically in the past and continue periodically into the future; and,

(3) the key events that shaped the large scale structure of the universe occurred during a phase of slow contraction before the big bang.

The painting "Chased by Time" (acrylic on canvas 30' x 40') expresses our ambivalent relation with the dimension time. Time is a force that drives us forward like a shepherd who drives his cattle towards other pastures while at the end of the road you only have the slaughterhouse. The difference between us and the unsuspicious cattle is that we know that at the end of the road there is the slaughterhouse, so we linger as long as possible. But time is driving us merciless forwards.

Tidal Disruption

*Tidal Disruption. Acrylic on canvas 24 x 36' by Shaharee Vyaas (Dec 24, 2021)*

This painting aimed to unite the boundless freedom of human imagination with the mathematical precision of the physical world by using the alchemic approach.

There exist are several historic detectable strands of alchemy that seemed independent in their earlier stages, including Chinese, Indian, and Western alchemy. The aim of alchemy was to purify, mature and perfect objects, through the process of chrysopoeia, the transmutation of base metals, search for and creation of the panaceas, including an elixir of immortality, and the perfection of human soul and body

In the late 19th and 20th century the fascination with alchemy among artists continued, but the motifs and use of alchemical knowledge in their works differ from the previous ages. Modernist artists have seen themselves as esoteric thinkers distinguished from others by the unique creative powers they possessed. The appearance of abstract forms in the last decades of the 19th century can be linked to practices such as

43

Anthroposophy, Spiritualism, Theosophy, and Buddhism. Rudolf Steiner and Theosophical Society influenced avant-garde artists from Piet Mondrian, Wassily Kandinsky, Kazimir Malevich, Marcel Duchamp, and Francis Picabia.

They reject the traditional concept of a work of art, and instead link it to the will of an artist who can elevate any object to art. Just like the catholic priests who claim they have the power to turn an ordinary small round waffle into the body of Christ through the so-called transubstantiation process during the consecration, the climax of every catholic mass.

In this perspective, every catholic priest is a greater artist than all conceptual artists who go around, declaring that everything is art what they consecrate to be art. The catholic priest at least offers a metaphysical concept that allows his flock to think-the-the-world-together. When everything can be art, nothing is art. Conceptualism is causing a massive artistical inflation. Just as the massive influx of robbed gold coming from the colonies into 16th century Spain rendered the metal almost worthless.

While I acknowledge that absurdism has its place in the artistical specter, I consider its value more as an anecdotical source of beauty and interest. Those works mostly relate to ancient archetypes that are explored by Jungian psychology and often feature prominently in ancient mythological worldviews.

I advocate a more balanced approach of the alchemist method in art. Artists have the freedom to explore visions that lay outside the teleology of the scientifically approach, they should nevertheless not keep themselves busy by getting lost in mystical nonsense that instead of offering a fresh perspective upon the reality, unnecessarily cloud and complicate the subject at hand.

Alchemy and astrology as proto-sciences can be excellent guidelines to explore the borderline where fantasy and knowledge are intersecting. My vision resonates with a quote by Francisco Goya: "Fantasy, abandoned by reason, produces impossible monsters; united with it, she is the mother of the arts and the origin of marvels."

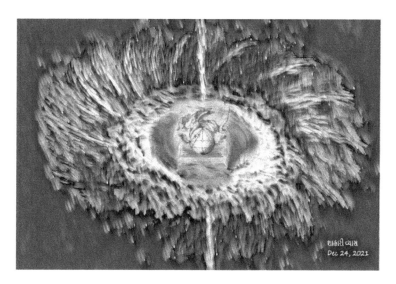

*The Hatching of Chaos. Acrylic on canvas 24' x 36' by Shaharee Vyaas (Dec 24, 2021)*

Chaos was originally identified as a vast, nonlinear space in which all possibility lies...the origin of everything. It denotes the necessity of everything being put into disorder to allow what's next to arise. Alchemy of Chaos is a pursuit to grasp more fully what is required to face reality, embrace radical change, and understand that what is here for you now is a set of ingredients that, if acknowledged and utilized, will allow you to create the metaphorical gold.

Tapping into the Alchemy of Chaos familiarizes you with a tool belt fit for leading through uncertain, volatile, and ambiguous seasons. This painting is designed to help see unseen paths, to imagine unimagined possibilities, to know unknown truths, to feel unfelt understandings. It invites a more grounded and self-aware way to be and to lead, beginning with coming to know who you are choosing to be now. This space is about experimenting with

the possibility of eliminating traditional strategic techniques to cultivate immense courage and immense vision.

The invitation for you is to become an alchemist. Step into the possibility that awaits you beyond strategy, beyond the mental monkey mind, beyond forecasts, and beyond what is "known".

Understand that alchemy is what happens during the process and is not found into the outcome. Everything is constantly into a state of flux of transformation taking place.

*Crossroads. Acrylic on canvas 24 x 36´ by Shaharee Vyaas (Nov 16, 2021)*

In folklore, crossroads may represent a location "between the worlds" and, as such, a site where supernatural spirits can be contacted, and paranormal events can take place. In Greek mythology, crossroads were associated with both Hermes and Hecate, with shrines and ceremonies for both taking place there. The herm pillar associated with Hermes frequently marked these places due to the god's association with travelers and role as a guide.

In nearly all countries, and at all times, special significance has been attached to the place where roads cross one another. In Christian times it was the spot chosen for the burial of suicides and condemned criminals. This practice seems to have arisen, not merely because the roads form the sign of the cross and so make the ground the next best burial-place to a properly consecrated churchyard, but because the ancient Teutons erected altars at

47

cross-roads on which they sacrificed criminals. Thus, cross-roads were of old regarded as execution-grounds. The chief fact prompting the choice of the special locality must be, I think, that just as a circle commands every direction, so cross-roads, pointing north, south, east and west, command every main direction, and the actual point of crossing is the only point where people coming from every direction must pass.

At the funeral of a Brāhman in India, five balls of wheat-flour and water are offered to various spirits. The third ball is offered to the spirit of the cross-roads of the village through which the corpse will be carried. Lamps are also placed at cross-roads. During the marriage rite among the Bharvāds in Gujarat, an eunuch flings balls of wheat-flour towards the four quarters of the heavens, as a charm to scare evil spirits; and in the same province, at the Holī festival, the fire is lighted at a quadrivium. In Mumbai seven pebbles, picked up from a place where three roads meet, are used as a charm against the evil eye. Some of the Gujarāt tribes, apparently with the intention of dispersing the evil or passing it on to some traveler, sweep their houses on the first day of the month Kārttik (November), and lay the refuse in a pot at the cross-roads.

In Africa cross-roads are largely used to effect cures. When a man is ill the native doctor takes him to a crossroad, where he prepares a medicine, part of which is given to the patient and part buried under an inverted pot at the juncture of the roads. It is hoped that someone will step over the pot, catch the disease, and so relieve the original sufferer. The use of cross-roads as a place for disease-transference is widespread: there exist examples of the custom from Japan, Bali (Indian Archipelago), Guatemala, Cochin-China, Bohemia and England.

My painting Crossroads symbolizes a metaphysical approach of the concept, using the five alchemistic elements to illustrate how our reality is a tissue made of constant interactions and choices. The element fire has been given a central place since it is the

48

catalysator between the other four elements (water, earth, air, and ether).

## Evolution: Entrance or Exit?

*Evolution: Entrance or Exit? Acrylic on Canvas 12 x 24' by Shaharee Vyaas (Nov 18, 2021)*

This painting features an octopod hovering in front of the gates of evolution, watched over by a malevolent shoggoth.

A scientific paper claims that octopods are actually aliens brought to Earth by frozen meteors. Why the octopus in particular? "Its large brain and sophisticated nervous system, camera-like eyes, flexible bodies, instantaneous camouflage via the ability to switch color and shape are just a few of the striking features that appear suddenly on the evolutionary scene." This terrestrial evolution occurred thanks to "cryopreserved squid and/or octopi's eggs" crashing into the ocean on comets "several hundred million years ago."

Above the gate floats a shoggoth. Everyone who´s familiar with the Lovecraft universe, knows that the shoggoths were a creation of the elder ones to serve them as slaves. In such a society the Elder Ones were free to pursue their interests in art, science and architecture. However, the obvious dark side to such a society is where one is free to purse one's interests, there has to be a group of entities present to perform the necessary tasks and labor to keep society going; this work was conducted by the Shoggoths.

While the enslavement of the Shoggoths allowed the Elder One's civilization to flourish, it was also their downfall. It appears that when the Shoggoths acquired the ability to reproduce through fission, it came along with a "dangerous degree of accidental intelligence", which caused problems for the Elder Ones. A shoggoth can shape itself whatever organs or into shapes it finds necessary at the moment; however, in its usual state it tends to sport a roiling profusion of eyes, mouths, and pseudopodia. It could be considered as the summum of evolutionary progress by our actual standards.

As such it remains unclear if the octopod stage marks the beginning or the end of our evolutionary tract. Or both.

# A Cosmology of Civilization: The Opera.

It was inevitable that, during the research for my own artistical activities, I would stumble upon the works of British composer Gustav Holst. Just as I do, he found inspiration for his work into the planetary system and in the Mahabharata.

The Planets, a seven-movement orchestral suite written by Holst between 1914 and 1916, has been from its premiere to the present day been enduringly popular, influential, widely performed and frequently recorded and keeps inspiring many contemporary composers. John Williams used the melodies and instrumentation of Mars as the inspiration for his soundtrack for the Star Wars films (specifically "The Imperial March").

The most important conceptual difference between my music and Holst's suite, is that his inspiration was astrological rather than astronomical. My work is based upon a sonorization of the electromagnetic waves emitted by the main celestial bodies of our solar system and includes Earth, the Sun, Uranus, and Neptune (the two last ones still had to be discovered when Holst composed his suite). In Holst's opera each movement is intended to convey ideas and emotions associated with the influence of the planets on the psyche, while in my work they are used as metaphors to illustrate the different cyclic phases of a human civilization. That is also why it is called "A Cosmology of Civilization".

Most of the music of Holst's Indian verse settings remained generally western in character, but in some of the Vedic settings he experimented with Indian raga (scales). In my compositions the variations in key, rhythm and meter were determined by the

strength, frequency and amplitudes of the electromagnetic waves emitted by the different elements of our solar system, translated into some good old Wagnerian composition, characterized by the use of propulsive repetition that includes also a palette of idiosyncratic instrumental touches, and some extreme high and low octave doublings.

The opera is divided twelve scenes, supplemented with a prologue and an epilogue, demonstrating the cyclical nature of human civilization where each phase is represented by a planet. The planets are grouped in four movements, each containing 3 planets, that indicate the start, ascend, descend, and end of each cycle and are respectively named, the bronze -, gold -, silver -, and iron - times. The prologue and epilogue are overflowing in each other, indicating how each end of a cycle gives birth to another one. The music is larded with some narrative that consists of the works of famous poets such as Keats, Byron, and many others ... Then some illustrations were made and the whole ensemble was mounted in a video of ninety minutes, that is also on display at the art show.

You can listen to the English version on You tube by clicking on this link.

https://www.youtube.com/watch?v=OW7CD1dwPa8&list=PLbQ fb6Qu48hGqa5cC7fRZIWIB0ktmlefT&index=1

# The Vignettes of the different parts of the Libretto.

Prologue: The Sun.

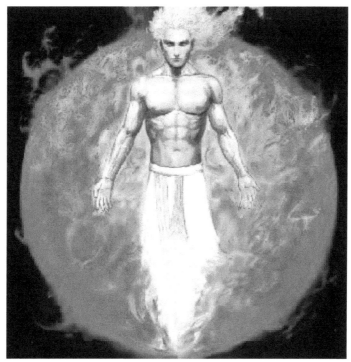

The sun god, digital art by an

Once upon a time, the sun god reflected upon his existence and found it dull. So, he created a World Egg. When the egg spawned, it gave birth to Eris, the goddess of Chaos, who danced the

53

universe into existence. Eris embraced the primeval ocean, out of which all life would grow.

When the breath of life grew strong and ready, the sun god dropped a seed into the ocean. Humankind emerged and looked at Eris for guidance. Eris took a golden apple upon which she wrote "for the fairest" and tossed it in the middle of the assembled crowd. Then she sat back and rejoiced the fights that broke out among the humans to take possession of the golden apple. When the fight was over, humanity wept, honoring the pain of all those who lost a beloved one. The sun god recognized the pain, and felt the suffering was an important part of the continuing process of healing. He decided it was time for civilization to begin.

1<sup>st</sup> Movement: The Bronze Times

Scene 1: Mercury.

Mercury. Detail from the Painting A Cosmology of Civilization. Civilization started when the World Egg spawned the gods' messenger: Mercury, the god of commerce, eloquence, and communication.

Mercury taught humankind to resolve their disputes through negotiation and trading goods instead of fighting about them. Soon it averred that some humans were better at accumulating goods and followers. The stronger ones started to distinguish themselves by wearing red hats, while their followers wore blue hats.

The red hats controlled all the resources and shared their wealth with the blue hats in return for their servitude. Through skillful maneuvering, one of the red hats became the biggest red hat and managed to become the king of all.

Meanwhile Eris was moving through the ranks of the blue hats, seaming discontent among them about the disproportionate

amount of wealth the red hats allotted to themselves while they were sent home with just enough to feed their families. The blue hats revolted but was repressed violently by the red hats and their mercenaries. A revolution occurred that made the world tremble and since the blue hats outnumbered by far the red hats, the revolution ended with the beheading of The King and the dissolution of the red hat class.

Scene 2: Venus

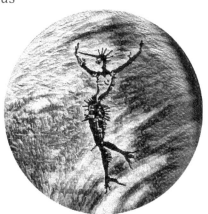

Venus. Detail from the Painting A Cosmology of Civilization

Because Mercury was at the end of his rope, the world egg spawned Venus: the goddess of love to solve the dispute about a fairer distribution of the cake of wealth. She started by declaring that there would be no red or blue ones anymore but only purple ones. Some purple ones would have bigger hats than others, but that would no longer be exclusively determined by how much wealth they accumulated. The big purple hats that were not rich managed to convince the rich big purple hats to give the small purple hats a fairer share of the wealth in return for their labor.

It was also convened that the new ruler would be elected every four years by all the purple ones and be called The President. To assure that there would be a fairer power balance between rich and poor, he was placed under the supervision of a body of elected lawmakers.

Scene 3: Terra

Terra. Detail from the Painting A Cosmology of Civilization

After Venus considered her job done, she retreated, and Mythopia prospered under the governance of Terra: de goddess of abundance. Till the humans in their arrogance disturbed natures balance by wildly cutting trees and poorly conceived agricultural techniques. The fertile soil turned dry and unfertile, which opened the backdoor to Eris, who managed to seam discontent among some who felt being left out under the New Deal.

They called themselves the black hats and found themselves superior to the purple hats. Since they were a minority, the purple hats ignored them, but the black hats secretly built a war-machine to reach their goal of dominance. With the help of their war-machine, they started to subjugate the nearby purple hats, and forced them to wear yellow hats. The black hats confiscated the wealth of the yellow hats and committed them to forced labor to enlarge the war-machine.

2nd Movement: The Golden Times.
  Scene 4: Mars

Mars. Detail from the Painting A Cosmology of Civilization
Finally, the president of the purple hats took notice of the plight
of the farmers and the threat the black hats posed. The world egg
spawned Mars, the god of war, and an agricultural guardian.

The god advised he purple ones first to regain their strength
before confronting the black hats. Their president ordered the
massive construction of waterworks and reforestation to
compensate for the poor agricultural techniques that caused the
erosion of the fertile soil, but while they were still at the job, the
black hats attacked the purple ones by surprise and destroyed
Mythopia's war fleet.

Mars wielded his spear and destroyed the black hats' war-
machine with an enormous lightning bolt. Thus, the war was over,
and Mars garlanded his spear with laurel leaves, symbolizing a
peace that is won by military victory.

Scene 5: Ceres

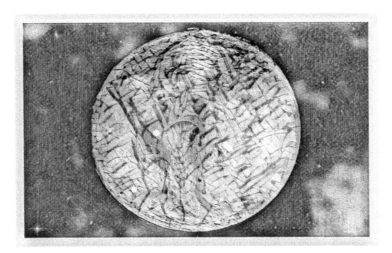

Ceres. Detail from the Painting A Cosmology of Civilization
Now that peace was won, Mars yielded place to Ceres, the goddess of agriculture and fertility. Many people died in the war and the fields had been unattended for too long.

Under Ceres governance abundance returned to Mythopia. The humans learned to use the destructive energy of Mars for peaceful purposes, and the arts and science blossomed. Human civilization reached a peak and swords were turned into ploughshares.

Still Eris managed to sow some discontent into the hearts of some smaller purple hats because their children did not have access to higher education, and they found that their labor was not well enough compensated. They organized in unions and civil rights organizations to protest the firm grip the big industrial conglomerates and the churches had upon their lives.

## Scene 6: Jupiter

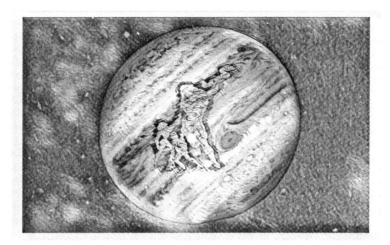

Jupiter. Detail from the Painting A Cosmology of Civilization

Ceres felt inadequate to deal with this discontentment and asked her brother Jupiter, the god of the skies and the thunder to take it over since he was more apt to deal with class conflicts as most of the other gods saw him as the ultimate source of justice. Under Jupiter's influence all educational institutions were opened to the small purple hats, and grants were given to those who showed excellence but could not afford the tuition fees.

Eris was thinking: "If you can't beat them, join them" and poked the Mythopians to reach for the stars. Several spacecrafts were launched to explore the mysteries of the universe. This endeavor reached its apotheosis when the first Mythopian placed a foot on the moon while declaring "A small step for a man, a big step for humanity".

Jupiter fumed, "They want to steal the light of the gods" and slammed the door on humankind.

SECOND ACT.

3rd Movement: The Silver Times.

Scene 7: Saturn.

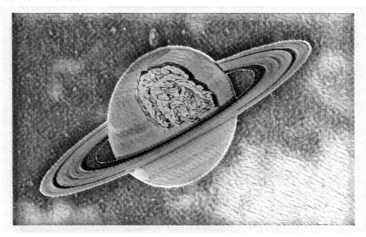

Saturn. Detail from the Painting A Cosmology of Civilization
When Jupiter left in anger, Eris managed to put her hands on the
keys of the prison where he confined his father Saturn. Saturn is
the god of dissolution and liberation. Saturn took a fashion for a
mortal woman called Marylyn, but she was the mistress of the
president of Mythopia. To satisfy Saturn and to advance her own
agenda, Eris arranged for the assassination of the president of
Mythopia.

Meanwhile, in a faraway country called Dystopia, the little purple
hats overthrew the government of the big purple hats and called
themselves green hats. The new president of Mythopia found
them a threat to the dominance of Mythopia and declared war
upon Dystopia. The Mythopian government sent an army to fight
the green hats in their own country.

Saturn lost his interest in humankind when the mortal woman he
loved committed suicide.

## Scene 8: Uranus

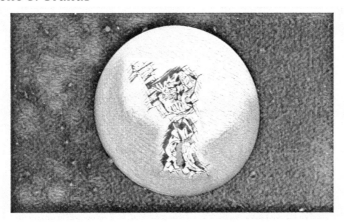

Uranus. Detail from the Painting A Cosmology of Civilization
Uranus rejoiced into the misfortune of the prodigious son who castrated and deposed him, to become the god of the night and the skies. Mythopia's space shuttles started to explode, limiting their space program to launch unmanned probes for commercial, scientific, and military purposes.

The little purple hats got tired of getting killed in a war against the green hats and did not see why Mythopia had to meddle with the way how the Dystopians wanted to organize their society. In protest, some of them started to wear little blue ribbons upon their little purple hats to indicate that the war only made the rich richer while the poor ones were sacrificed in wars that served Mythopia's hegemonic politics and business.

In return, some of the other purple hats, started to wear red ribbons to indicate their support for their country's war against the green hats. But eventually, the war started to wear out Mythopia's economy and its work force. The big purple hats decided it was time to leave Dystopia to its own devices and withdrew from the war, leaving the green hats in charge of Dystopia.

Scene 9: Neptune

Neptune. Detail from the Painting A Cosmology of Civilization

A severe drought struck big parts of Mythopia. Harvests failed and many Mythopians lost their houses and belongings in major bush fires. The economy started to falter and disputes about water rights erupted between cities and farmers. Neptune, the god of the sea and the water wells emerged.

He fostered consciousness among the Mythopians about heeding nature's balance. The Mythopian big purple hats were afraid that his advice would affect their industry and chose to ignore it. Instead, they started a trade war with Dystopia, who retaliated by boycotting Mythopia´s soyabean farmers.

Out of anger, Neptune started to support Dystopia's attempt to break the hegemony of Mythopia's fleet over the oceans. Soon the import of all kinds of raw materials to Mythopia became more expensive while more and more farmers were edging closer to the abyss of bankruptcy. Lots of small purple hats lost their jobs and even some of the bigger hats their fortunes. Eris thrived and needed little to do to create a wave of discontentment. Soon everyone threw away their purple hats and started to wear again red and blue hats.

4th Movement: The Iron Times.

Scene 10: Pluto

Pluto. Detail from the Painting A Cosmology of Civilization

When the political climate in Mythopia degraded and mass shootings increased, Pluto, the god of the underworld made his entrance. He found the planet overpopulated and its wealth unevenly distributed.

He used his key to open the gate of the underworld. A pandemic broke out and the already crippled economy of Mythopia degraded further. Many people died and lots of small business went into bankruptcy. Only a couple of big consortiums where thriving upon the crisis while wild capitalism made a revival. Public schools became the playgrounds for street gangs and higher education institutions were reduced to degree mills that were only teaching the test. The political elite of Mythopia degenerated into a couple of self-serving clans who were inciting their followers into violent clashes.

The destitute citizens of Mythopia took their grievances to the streets and started to loot and plunder. Finally, Mythopia's

65

government had to declare martial law and send in the army because the police could not manage anymore the violent crowd. Eris exulted.

Scene 11: Charon

Charon. Detail from the Painting A Cosmology of Civilization
His job done, Pluto transferred his tenure over to Charon, the ferryman of the underworld.

The Mythopians got tired of their traditional policymakers and elected a demagogue to become their next president. This president declared that all evils that were bestowed upon Mythopia were caused by the denizens of Dystopia. He started to impose trade embargos and ordered Mythopia's warships to regain the dominance over the oceans. Soon the war drums started to sound. But the Dystopians were better prepared for war than their divided adversaries, and Mythopia was facing a

humiliating defeat. In a last effort to turn the receding tide, their president decided to use the Spear that Mars had left behind when he retreated.

But without the guidance of Mars, the lightning bolt rebounded and hit Mythopia. Charon ferried the last remnants of civilization to the underworld.

Scene 12: Eris

Eris. Detail from the Painting A Cosmology of Civilization
Eris presides over the ruins of what remains of Mythopia.

The central government of Mythopia had collapsed and the country's infrastructure was in ruins. Only small pockets of order ruled by local warlords remained, while robber gangs were roaming the open plains, plundering food and the remaining reusable goods.

In the end, when Eris regained her throne, she declaims:

*I am chaos. I am the substance from which your artists and scientists build rhythms. I am the spirit with which your children and clowns laugh in happy anarchy. I am chaos. I am alive, and I tell you that you are free....*

... sits down upon her throne that slowly closes and becomes again the World Egg rising back towards the skies.

## Epilogue: The Sun

The World Egg returns, and the rest of the pantheon performs a choreography around Eris and Apollo.

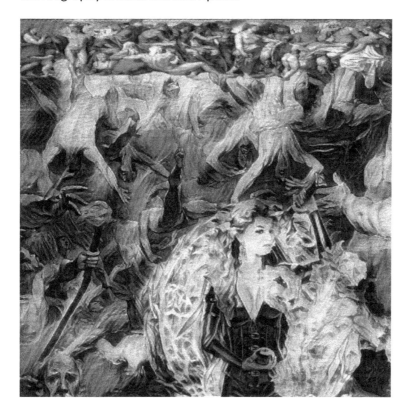

Dancing Titans. Acrylic on canvas 50 x 50 cm by Urban Vyaas

Tis true without lying, certain and most true.

That which is below is like that which is above
and that which is above is like that which is below
to do the miracle of one only thing

And as all things have been and arose from two by the mediation of one:
so all things have their birth from this two by adaptation.

The Sun is its father,
And Eris its mother,
the wind hath carried it in its belly,
the sea is its nurse.
The father of all life in the whole world is here.
Its force or power is entire if it be converted into earth.

Separate thou the earth from the fire,
the subtle from the gross
sweetly with great industry.
It ascends from the earth to the heaven
and again it descends to the earth
and receives the force of things superior and inferior.

By this means you shall have the glory of the whole world
and thereby all obscurity shall fly from you.

Its force is above all force,
for it vanquishes every subtle thing and penetrates every solid thing.

So was the world created.

From this are and do come admirable adaptations
where of the means is here in this.

Hence I am called Hermes Trismegistus,
having the three parts of the philosophy of the whole world

That which I have said of the operation of the Sun is accomplished and ended,
To make place for a new beginning.

The title of the novel, The Maharajagar , is a self-coined portmanteau through combining parts of the Hindu words; **ma**haan (great), **har**e (green) and **ajagar** (dragon). The main purpose of this novel is to entertain the reader with a historical fantasy: a spellbinding epic tale of ambition, anarchy and absolute power, set against the canvas of North America, Europe and Asia during World War 1 and the ensuing great depression.

This derivate of the Mahabharata contains several textual, biographical, temporal, and topographical discrepancies during its adaption to a contemporary novel, as do the names and some facts derived from the lives of real people in a variety of often unexpected ways to recreate the life-stories of its protagonists.

The novel uses metaphors, symbols, ambiguities, and overtones which gradually link themselves together to form a network of connections binding the whole work. This system of connections gives the novel a wide, more universal significance as the tale

becomes a modern microcosm presented from a fictive metaphysical perspective and can be described as the "mythic method": a way of controlling, of ordering, of giving a shape and give significance to the immense panorama of futility and anarchy which is contemporary history.

Although this is a work of fiction, there are nevertheless three meta-themes interwoven with the tale of the Maharajagar;

- The All is a projection of informational modulated energy waves by a

- cosmically horizon on the time-space continuum.

- Synchronicity is a phenomenon that comes to us with a message.

- The Long Now is the only time concept to give a lasting meaning to our thinking and, hopefully consequent, actions.

These principles offer a perspective from where a powerful code of conduct can emanate, transforming our lives to a new experience of freedom, happiness, and love.

## Social Entropy

### The Meaning of Life = 42

Porcupinefish are also called blowfish because they can inflate their bodies by swallowing water or air, thereby becoming rounder. This increase in size (almost double vertically) reduces the range of potential predators to those with much bigger mouths. A second defense mechanism is provided by the sharp spines, which radiate outwards when the fish is inflated.

I like more the name blowfish, because it allows me to relate to some characteristics that can be found in human behavior. For example, the wish to look bigger, more important, and a bigger menace then one really is.

I have been wasting a weekend on this visual arts project instead of working on the fourth part of my series. It all came along when I showed my other better half a picture of a blowfish and she mooned "can't you do something artistical with that?"

The first image that popped into my head was the goldfish in a bowl that figures prominently in Monty Python's "The Meaning of life", so it's not astonishingly that the first thing I came up with looked like this:

*The Meaning of Life 1. Acrylic on canvas 30 x 20' by Shaharee Vyaas (2021).*

73

And no, that particular design didn't take me too long. About an hour or so. It's just that it deviated my thinking processes towards unexpected paths that made me contemplate about what people believe is the meaning of life. After some reflection I decided that there are three things that most people seem to believe worthy to strive for: wealth, eternal youth, and power. Most marketing campaigns center around one, two, or all three of these three subjects.

In the following design you see a mermaid holding a flask containing the elixir of eternal youth, who's chased by a shark. Below her you find a blowfish carrying a nazi symbol in his mouth, who symbolizes the megalomaniacally rhetoric of many power-hungry politicians with their inflated egos. Under them you have a sea monster that bears some resemblance with a moray eel that chases a bundle of banknotes. Under it you have an evil grinning clown fish. In the left corner under you can see what an Einstein goldfish answers when asked about the meaning of life, while in the right corner at the bottom you have a Tsubaki goldfish staring in bewilderment at the stone that carries the title of this painting. In the left part of the painting, you find yours truly when I was a couple of years younger and still in my hammerhead phase of a becoming human being. That was the story of how the blowfish stole my weekend.

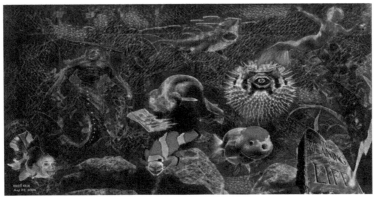

*The Meaning of Life = 42. Acrylic on canvas 40 x 20 cm by Shaharee Vyaas (2021*

During the last week of November 2021, I attended the Asian Film Festival 2021 in Barcelona. Because of practical agenda issues I saw only four of the movies:

Hand Rolled Cigarettes

Faeries—as the myths say—are small,

- (Hong Kong): Chiu is a retired member of the Hong Kong Military Service Corps of the British Army, and now ekes out a living doing odd jobs. Mani is a small-time drug dealer who gets into serious trouble when his cousin steals a stash of drugs from him. While on the run from the criminal organization, Mani is taken in by Chiu and takes refuge in his apartment. The unusual living arrangement forces the two men to overcome their cultural and racial differences.
- Fire on the Plain (China): This dramatic thriller takes place in China in 1997. A series of murders strikes the city of Fentun. The crimes mysteriously stop without the authorities being able to find the perpetrator. Eight years later, a young policeman close to one of the victims decides to reopen the investigation despite all the consequences it brings. His discoveries disrupt the fake outcome that had brought to an end the scheme.
- I met a Girl (Australia): follows the story of Devon (Breton Thwaites), an aspiring musician with schizophrenia who is dependent on his older brother, Nick (Joel Jackson) to care for him. However, when Nick's wife, Olivia (Zahra Newman) becomes pregnant, they arrange for Devon to move out. On a downward spiral, Devon is saved by Lucy (Lily Sullivan) a mysterious girl who is just as impulsive and romantic as he is. After one day together, they fall completely in love. Devon then arranges for Nick to meet her, but Lucy doesn't show. They try to find her but her apartment is empty. Nick suspects that Lucy is a delusion,

75

while Devon, desperate to prove his sanity, discovers a note that she wrote him: meet me in Sydney. And Devon sets off on an epic, cross-country journey to find her; the girl of his dreams... who may be all in his head.

- 1990 (Mongolia): After the fall of the USSR, Mongolia suffers a wave of violence, corruption and disorder. The citizens do their best to survive in an uncertain era dominated by chaos, uncertainty, violence... At the same time, Western influences arrive in the country and become popular among the youth.

It stroked me that most movies played into a time space where the old order collapsed, leaving people disoriented and to fend for themselves. The biggest difference between the movies I could discern was between the Australian movie and the other ones. The latter follows the Hollywood script of a happy ending while the Asiatic ones where not so hung up on a happy ending and portraited people more like they are.

For example, in Anglo-Saxon movies you rarely see a "good" protagonist smoke, drink, or display ambiguous moral behavior without a redemption arc. They usually have a happy ending. Not so in Asiatic movies: they paint a more morally greyish image of their protagonists. The "good" as well the "bad" ones. Not mention that they often have an ending that would not be appreciated by a Hollywood public: either they die or turn events into their advantage by committing some robbery, murder, or blackmail. In short, in most Asiatic movies the "good protagonists" mostly reach their desired goals by either sacrificing their lives or their moral integrity.

No-Man's-Land, indicates faults into the time/space of human society where an era comes to an end while transiting to another one. The Asiatic movies I saw showed how on one side of China the Soviet Union collapsed, while on the other side the West was moving out of China's border regions Hongkong and Macau, leaving populations on both sides of the country who lived across those borders in a societally limbo. At the same time China itself

made the transition from a Marxist economy towards a free market economy with all the angles of wild capitalism that this entailed.

During World War I, No-Man's-Land was both an actual and a metaphorical space. It separated the front lines of the opposing armies and was perhaps the only location where enemy troops could meet without hostility. I found inspiration for this canvas in a lithograph by Lucien Jonas No Man's Land from 1927 that I further adapted to my own liking.

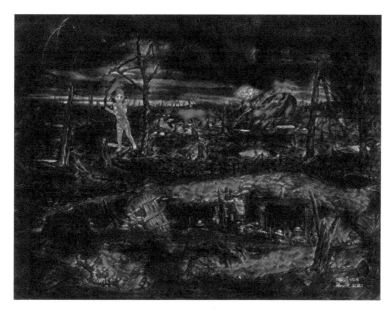

*No-Man's-Land. Acrylic on canvas 24 x 32'' by Shaharee Vyaas (Dec. 09,2021)*

Greed

Few 20th-century visual artists accepted the Industrial Revolution with as much enthusiasm as Andy Warhol. A pivotal event was the 1964 exhibit The American Supermarket, a show held in Paul Bianchini's Upper East Side gallery.

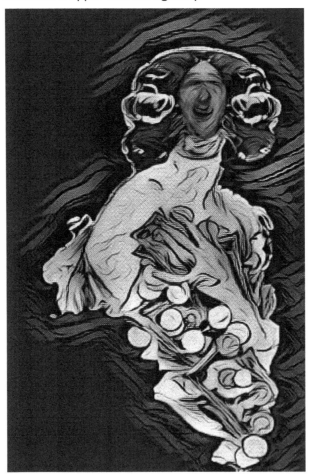

Greed. Acrylic on canvas 20 x 30' by Shaharee Vyaas (2020)

The show was presented as a typical small supermarket environment, except that everything in it—from the produce, canned goods, meat, posters on the wall, etc.—was created by prominent pop artists of the time. The exhibit was one of the first

mass events that directly confronted the public with both pop art and the perennial question of what art is, slowly eliminating the handmade from the artistic process. Warhol frequently used silk-screening: his later drawings were traced from slide projections. At the height of his fame as a painter, Warhol had several assistants who produced his silk-screen multiples, following his directions to make different versions and variations. Some critics have come to view Warhol's superficiality and commerciality as the most brilliant mirror of our times, contending that Warhol had captured something irresistible about the zeitgeist of American culture in the 20th century. From thereon we can see a reverse into the culture of making art more accessible for society in general towards a refocus upon its exclusivity.

Where the artists of the sixties claimed that their works should be available for the public in general, I detect the resurgence of the tendency to make art for the happy few who can afford it. Hence you get artists who want to emphasize the uniqueness and artisanal aspects of their creations by posing with the traditional tools of their craft. Most artists have sooner or later to make a choice if they want to create art for the happy few or make their work available for a broader specter of society. My personal hero in this aspect is Alexander Rodin. Rodin's most inspiring works are rarely for sale, but the artist gladly sells signed posters with reproductions of his works or puts them up for expositions. That's how he distillates a living from his art.

I believe that The Middle Way of Aristotle can reconcile the need of the artists to make a decent living while still reaching with their works a substantial part of society. Aristotle is not defending mediocrity. He is advocating for a life most fully lived. Laugh at life, said Nietzsche. Aristotle would agree. But he would also say to be careful that that laughter does not turn to mockery.

In 2010 Parasite Artek formulated a "Manifesto of Parasitism" presenting the idea of his activities as a parasite-artist. According to these ideas covered in "Manifesto", Parasite Arek lived, worked, and created parasitizing for four years in several cities, cultural institutions and all places of culture. With time, his actions turned into a critique of the status of the artist in society and he began to create the so-called host projects.

In this spirit, in 2012, he created a series of activities "Willing to help" implemented in Polish villages and towns. In 2013, he designed and completed the construction of a home in Elblag – a house, which is the dream of every young person who has no money for land, materials, and builders. Then he worked in various projects with social groups referred to as "social parasites": Roma, the long-term unemployed or experiencing social exclusion; a painting workshop "Not to be Rejected", where homeless people can work. At the basis of this and other activities is the belief in the therapeutic role of art and the belief that people can improve their situation through it.

"The Socio-Parasitology Manifesto" from 2018 by Sabrina Muntaz Hasan looks at all points of contact as interruptions that are exercised by the parasite. Although most of Hasan´s work centers around immigration topics, her observations can be applied to other social issues. According to Mumtaz Hasan, all humans are parasitic. The focus is on interruption and not disruption, looking at the socio-parasitic relationship in a progressive way.

You need to interrupt in order to have agency
You need to interrupt to become positive
You need to interrupt so you are parasitic
-               The Socio-Parasitology Manifest by Sabrina Mumtaz Hasan

Essentially, Mumtaz Hasan's theory focuses on a positive "parasite-host" relationship. In biological species relationships, parasites have a host; in this case the "parasite" is the artist, and

the "host" is the "benefactor". The manifesto looks at how the point of interruption — where the parasite and the host engage or "interrupt" each other — is actually beneficial for the new hosting environment.

In 2020, the Kunsten Museum of Modern Art in Aalborg, Denmark, lent the artist Jens Haaning 534,000 kroner (~$84,000) to reproduce two of his older artworks. But what did he do instead? He kept the money to himself and renamed the series Take the Money and Run. According to a written agreement between the two sides, Haaning was expected to utilize the banknotes from the payment to recreate two pieces he made in 2007 and 2010. The original artworks represented the respective average annual incomes of Austrians and Danes using cash bills. But for his latest, Haaning delivered two empty frames, with no banknotes to be seen.

This story of a cunning artist and an unsuspecting museum will make you rethink what conceptual art can get you. Haaning inhabited the museum as a foreign agent, adopting tactics that offered practical and conceptual strategies of artistic production through acts of "parasitical inhabitation." He took the opportunity to portrait the artist as an irritant, an organism that lives in or on another organism, extracting what it needs from its host without giving anything positive in exchange.

Since Marcel Duchamp in 1917 presented Fountain, a mass fabricated urinal that became art by a so called "transubstantiation process" (it just became art because he said so and was sold in 1999 for $1,762,500 ), a long train of parasitic artists have followed suit. That said, the exhibition Work it Out includes work that criticizes the impact of the parasite.

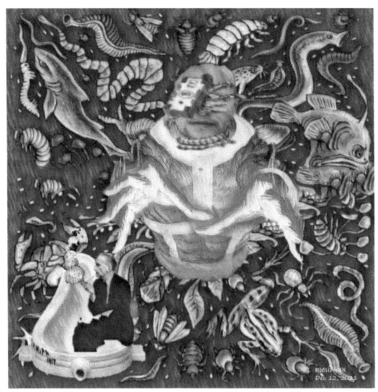

*Amazing Parasites. Acrylic on Canvas 40 x 40´ by Shaharee Vyaas*

This is a painting about an announced disaster. Everyone with some grain of common sense knew that with the start of the traditional flu season The Bug would strike again. And yeah, there

you have its latest spawn that has been baptized Omicron.

What actually nerves me is the amount of people in Western countries who had plenty of opportunities to get a vaccine, are now filling up the IC beds. Like the sixty years old vaccine refuser Valentin who lies since October on the oxygen in an IC unit. It goes better with him since they took him from the respirator, but he will need a double lung transplantation because the virus destroyed his lung tissue.

Meanwhile, my brother can't get his cancer operation because Valentin lies in his bed. The operation has been postponed till January. If the cancer hasn't spread by then, and if Valentin doesn't jump ahead of him to get his transplants. Don't even get me started about who will pay for Valentin's choice of not getting vaccinated.

And yes, also vaccinated people land on the IC unit. Mostly the old and the sick who have a weaker immunity system that makes the vaccine less effective. 80 % protection is not 100 %, so

The Joyful Entry of Omicron. Acrylic on canvas 30 x 30' (Nov 30,

vaccinated people still can get Covid, but as far as the statistics go, there is almost no incidence of healthy vaccinated adults landing on IC or dying because of Covid.

It's also not very astonishing that most variants come to us from countries where the vaccination rate is very low. As long the virus can circulate, it will keep mutating, and produce other variants. Non-vaccinated people are Covid-variant producers and it's probably just a question of time before the highly contagious but not very lethal Covid virus (mortality about 2.5 %) will fuse with a lethal flue variant. Like the bird's flue H5N1, who has a mortality rate of a staggering 60 %, but is luckily not very contagious. Unless it would team up with a Covid variant. Cross my fingers it won't happen, but this is a strong case where Murphy's Law may come down hard.

Omicron is here to stay for the remainder of the flu season. Let's hope it's not any nastier than its Delta cousin and that our vaccines will hold out against it. And make the vaccine compulsory and damn the refuseniks with their laments about their constitutional rights. My brother too has constitutional rights. While the statistics are very precise about the amount of people that died on Covid, there is an equally big number of people who died unnoticed because they didn't get the care they needed. Collateral damage I suppose?

Lost

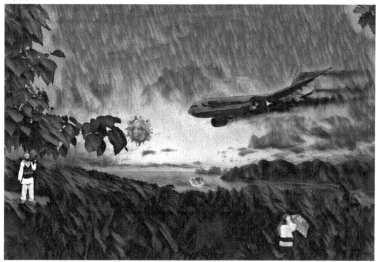

*Lost. Acrylic on canvas 60 x 80' by Shaharee Vyaas (Dec 13, 2021)*

Lost is a painting that expresses a feeling that's very common nowadays. It features some African people who rather risk their lives by crossing a sea in an overloaded shaky dingy than to suffer a miserable existence in their homelands, the Arab man who finds no better purpose in life then to become a suicidal terrorist, and the Western woman who´s looking for guidance on a failing map. All this happens under the light of a looming Omega-virus.

The inspiration of this painting came to me after a hike along a jungle trail to see the biggest waterfall of Central America at Pico Bonito in Honduras. The trail was meandering alongside of some steep cliffs and at some points was barely one foot wide, with a deep ravine on one side and a a steep solid rock wall on the other. There was only a rudimentary sketch of the trail available that had to serve as a guidance, and of course no cell phone signal available to make google maps work. So you had to figure out your trajectory more or less on the whim, while you had to dedicate 90 % of your attention to the next step you wanted to take if you didn´t want to end up as a meatball at the feet of the cliffs or with a snake bite.

I came to appreciate how this hike had many similarities with the way lots of people have to maneuver through life: step by step, with a sketchy map, driven by some vague purpose. In the jungle you need a constant eye for not stepping upon a snake or a loose stone which would give your nearby future prospects a very bleak outlook.  Similarities can be found into the lives of people who live at the edge of society: a misguided word, act, or gesture can carry deep running consequences.

I feel pretty sure that the suicidal terrorist hasn't been born with an innate destructive drive and that the Africans who migrate north would also prefer to stick around their relatives and houses. And all that plays against the canvas of a worldwide pandemic with a virus that rapidly mutates towards an omega variant.

Also, many Western people are at loss into in an increasingly complicated world where you need half day to dig through a pile of red tape before you can board an airplane, make a tax declaration, or do whatsoever. Most Western people must scramble to earn a decent living and then have to scramble to keep their earnings. Not many can afford the luxury of setting out a course through life of their own liking or to take a pause to see where the path they're walking is bringing them. Many are drifting through life without a decent map or compass, with only a vague impression of where they're heading.

Map of the Planetary Time – Space Continuum.

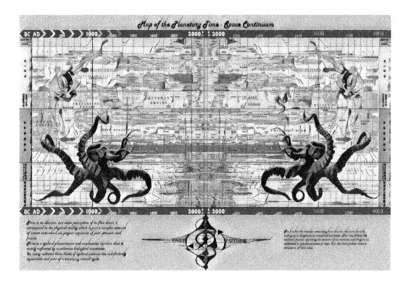

*Map of the Planetary Time – Space Continuum. Mixed media on paper 20 x 30'  by Shaharee Vyaas (Jan, 2022)*

The Front Yard of Eden

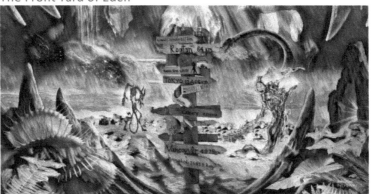

*The Front Yard of Eden. Acrylic on canvas 12 x 24'  by Shaharee Vyaas  (Dec 17,2021)*

After some cumbersome trekking I arrived at the center of my artistic universe. To reach the front yard of Eden, the curious explorers will need to leave the beaten tourist trail and be willing to do a 200 km overland hike from the nearest by international airport, followed by a 40 minutes boat trip.

As the name and the image indicate, it's a beautiful place, but also one that eats the careless ones. Cocaine and alcohol are cheap and abundant: the temptation is insane. I know many expats who've met an early grave because of substance abuse.

And then you have the do-gooders who arrive here with a soap box under their arms to preach Jesus, democracy, ecology, and fairness from the walls of their ivory towers. They´re tolerated as long they´re distributing money and other goodies but ran-off by the locals as soon as they started to interfere with local politics, customs, or believes.

Another category consists of the sufferers of a midlife crisis, the retired blue collars, the disillusioned war veterans, etc..... They come here and pick up a young girl in the firm believe that she´s attracted to their manly maturity, to find out that in the end they were only perceived as a walking wallet and end up as bar flies.

No paradise without snake, but for the ones who manage to avoid the obvious traps, this place can be a very rewarding experience. Its beauty is inspiring, the people friendly (as long you respect the previously mentioned boundaries), and the weather is yearlong agreeable when you disregard the rainy season with its occasional hurricane (the last big one was like 25 years ago: the people who're old enough still talk about it, but 50 % of the population doesn't qualify, and think it's old people's ranting).

As part of the Finger Mullet Film Festival, and curated by students in Flagler College's Curatorial Studies course, this exhibition will focus on work that visualizes, records, depicts, and investigates, the present and future of a partially submerged world. From imagined futures to the real social and economic consequences of climate change, the exhibition aspires to new ways of seeing and understanding coastlines, tidal shifts, displacement, submerged infrastructures, and other inundations.

Meteorological observations indicate that our climate is changing. You can´t debate observations.

What you can debate is the cause of climate change and its possible impact. Is climate change a cyclical phenomenon that runs over centuries? Is this process influenced or accelerated by human activities? Is it a combination of both? How fast is the climate changing and what will be its impact? That can be subjects for debate.

There are strong indications that climate changes are recurring events.

Everyone who paid attention in history class, must have heard of the Ice Age. The Ice Ages began 2.4 million years ago and lasted until 11,500 years ago. About 10,000-12,000 years ago most of the large mammals from the Ice Ages went extinct.

The curious thing about ice ages is that the temperature of Earth's atmosphere doesn't stay cold the entire time. Instead, the climate flip-flops between what scientists call "glacial periods" and "interglacial periods." Glacial periods last tens of thousands of years. Temperatures are much colder, and ice covers more of the planet. On the other hand, interglacial periods last only a few thousand years and the climate conditions are like those on Earth today. We are in an interglacial period right now. It began at the

end of the last glacial period, about 10,000 years ago. Scientists are still working to understand what causes ice ages and discuss the impact of human activities on these changes.

Human history and folklore are riddled by tales of sudden climate changes: the Biblical flood that caused Noah to build his arch and Plato´s tale of the city of Atlantis who disappeared into the sea are among the best-known legends. Noah built an arch filled up with stock he would need to start over again. The location of Atlantis was a long-time mystery, till some scientists located in the vast marshlands of the Dona Ana Park in southern Spain a multi-ringed dominion in some mud flats, swamped by a tsunami thousands of years ago. Atlantean residents who did not die in the tsunami fled inland and built new cities there. These tales contain indications of the previous ways people dealt with a sudden climate change

Because climate changes can run over millennia, the idea that human activities could influence that cycle seemed to be farfetched. Till in the 1820s, French mathematician and physicist Joseph Fourier proposed that energy reaching the planet as sunlight must be balanced by energy returning to space since heated surfaces emit radiation. But some of that energy, he reasoned, must be held within the atmosphere, and not return to space, keeping Earth warm. He proposed that Earth's thin covering of air—its atmosphere—acts the way a glass greenhouse would. Energy enters through the glass walls, but is then trapped inside, much like a warm greenhouse.

This greenhouse effect is at the center of the debate how $CO_2$ pollution of the atmosphere is causing an abnormal and steep rise of temperatures around the planet.

The Bull and the Bear is a painting that illustrates both sides of the debate. On one hand the established industrial lobbies and their shareholders, on the other the environmental consequences of their actions.

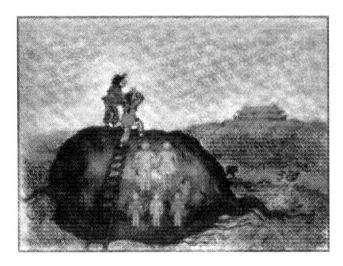

Then you have the logarithmic growth of the planet's population. At the current growth rate, we're looking at a world population of 12 billion consumers by 2050. Hence, the most populated country in the world, China, had to introduce a one child policy because there wasn't enough agricultural land to feed its population. Meanwhile demographers are screaming doom and hell about the reversed age pyramid in China, while it's just an example that the whole world should follow. We urgently must get rid of our obsession with growth and focus instead upon

sustainability. Overpopulation is the driving force behind the increasing CO2 emissions.

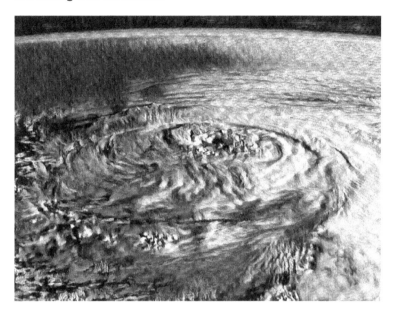

Neptune and Katharina waltz over New Orleans gives us an idea how the climate change will influence our future coastline.

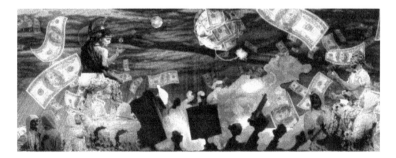

Can you imagine what will happen into the near future when 400,000 people will have to move upstream on a short notice? It´s safe to say that Katharina was just a warning shot for troubles laying ahead.

Rising temperatures not only cause the polar ice caps to melt and the sea levels to rise but are also responsible for the desertification of big stretches of previously fertile lands. The world population grows, while the sweet water access shrinks.

Pistols n Poppies

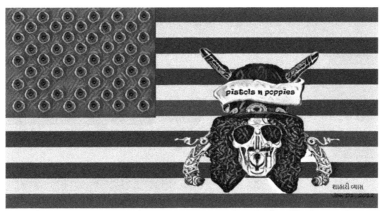

*Pistols n Poppies, Acrylic on canvas 12 x 24´by Shaharee Vyaas
(Jan 1, 2022)*

We often think of Freud as having suggested that everything can be interpreted in the context of sexuality, so the imagery of shooting bullets through a cylindrical barrel is hard to ignore. This is especially true when we acknowledge that the most gun violence and nearly every case of mass shooting is perpetrated by men. Thinking along those lines seems to be consistent with the observation that gun violence among men — especially in the context of mass shootings where perpetrators are haven mostly been white — is sometimes about compensating for feelings of impotence with fantasies of revenge that often end in suicide, or the perpetrator being killed by law enforcement. Going out with a bang, if you will.

Red poppy flowers represent consolation, remembrance, and death. Likewise, the poppy is a common symbol that has been used to represent everything from peace to death and even simply sleep. Since ancient times, poppies placed on tombstones represent eternal sleep.

*Make Russia Great Again. Acrylic on canvas 64' x 36' by Shaharee Vyaas (2022)*

This painting features the Russian president Vladimir Putin as the Big Pacificator who set as goal to denazify Ukrain at all cost and to send its indoctrinated population to reeducation camps in Russia so they can be made aware of their false believes and realize that there exists no future for their country if they persist in their misguided ideology. For their zionist fascist leaders there remains one Final Solution: extermination. Only then there will be peace.

Assimilation.

*Assimilation. Acrylic on canvas 60' x 60' by Shaharee Vyaas (Jan 16, 2022)*

This painting has the tension field between individuality and cultural assimilation for subject. While it´s a generally accepted fact that progress of civilization is a process of assimilation, one must conclude that inevitably there is going to exist a tension field between progress and multiculturalism.

The best example that comes to mind to illustrate this comes from the Star Trek series and is called The Borg. The Borg are cybernetic organisms (cyborgs) linked in a hive mind called "the Collective". The Borg co-opt the technology and knowledge of other alien species to the Collective through the process of "assimilation": forcibly transforming individual beings into

"drones" by injecting nanoprobes into their bodies and surgically augmenting them with cybernetic components. The Borg's ultimate goal is "achieving perfection".

When it comes to the progress of civilization, "achieving perfection" would probably be on top of the list. Lots of social projects exist where people have been experimenting with utopian ideas to create a perfect community. There are socialist, capitalist, monarchical, democratic, anarchist, ecological, feminist, patriarchal, egalitarian, hierarchical, racist, left-wing, right-wing, reformist, free love, nuclear family, extended family, gay, lesbian and many more utopias [ Naturism, Nude Christians, …] Utopianism, some argue, is essential for the improvement of the human condition. But if used wrongly, it becomes dangerous. Utopia has an inherent contradictory nature here.

After assimilation by The Borg, a drone's race and gender become "irrelevant". Does that ring a bell with someone? The strange thing is most liberal thinking people also promote cultural diversity, but simultaneously want to reject from these cultures all aspects that conflict with race or gender equality.

It is a puzzle that is difficult to resolve. It´s clear that the Western culture is at this instance the dominating civilization model and that other cultures have absorbed enormous portions of its realizations, but sadly enough also a big amount of the flaws that are inherent to this worldview.

The fast food, the secondary orality through TV addiction, the waste of natural resources, an economic system that dangerously depends upon continuous growth, a democratic political system that is dominated by a couple of self-serving clans, … just to name a couple of them.

Civilization is a circular process and at this instance it moves towards a recalibration where different cultures start to question openly the superiority of the Western cultural model over their own (upgraded) traditional values.

These issues lay at the foundation of the painting "Assimilation" (acrylic on canvas 30' x 30'). At the center of the painting you find a cube, which is my version of The Borg, a metaphysical

mechanism that assimilates the different cultures towards
"perfection". This cube is surrounded by a circle dominated by
Lord Yama, the Hindu god of Death and Justice, the ultimate
assimilator. The next ring represents the wheel of change that
symbolizes the circular and multicultural aspect of the
civilization process. At the fringes of the painting I've depicted
some aspects of the current evolution of civilization. I´ve also
used the metaphor of the cyclotron to put forward how
technology is one of the driving forces of assimilation, together
with the spreading of the fast food concept and the expansion of
the internet.

Other works on display.

Circle of Life by Camille Dela Rosa

Three subjects are presented sequentially in the next painting, aptly titled "Cycle of Life", as if to remind us at of one of the essential themes of this exhibition. Science has proven to us the conservation of matter and energy. Life itself must devour life to live and live again. Elements such as the coiled creatures eating flesh, man's predecessor eating the man eating the reptile, and jaws of the sharks consuming the man consuming his brain, all repeat the same story. One cannot really destroy that which has been created. Only transformation, and therefore conservation, remains the only action.

Circle of Life. Acrylic on canvas 50 x 40 cm by Camille Dela Rosa (2009).

The Global Brain by Mike Lee.

The artist commented on his website: "This graph is by far our most complex. It is using over 5 million edges and has an estimated 50 million hop count. We will be producing more maps like this daily. We still have yet to fix the color system, but all in due time."

The global brain is a neuroscience-inspired and futurological vision of the planetary information and communications technology network that interconnects all humans and their technological artifacts. As this network stores ever more information, takes over ever more functions of coordination and communication from traditional organizations, and becomes increasingly intelligent, it increasingly plays the role of a brain for the planet Earth.

Poster 50 x 40 cm by Mike Lee, Classic OPTE Project Map of the
Internet 2005, Source: www.opte.org/maps/

Graph Colors:

Asia Pacific - Red

Europe/Middle East/Central
Asia/Africa - Green

North America - Blue

Latin American and
Caribbean - Yellow

RFC1918 IP Addresses -
Cyan

Unknown - White

## Quantum Gravity.

Quantum gravity deals with reconciling the beautiful geometric description of space and time laid out in Einstein's theory of general relativity with the insight that all of physics at its most fundamental level must be described by quantum laws of motion.

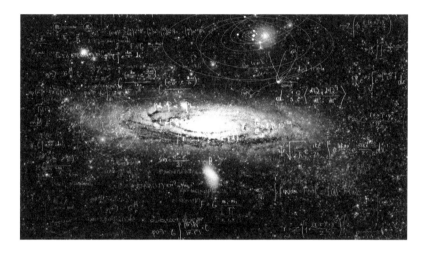

Poster of 62 x 34 cm by unknown artist

originated in the Great East Japan Earthquake disaster of 2011. The artist uses his expressive capabilities to depict in juxtaposition the continuously recurring existence of disaster throughout the world and to illustrate in a light and imaginative style the relationship between disasters and humanity. Rebirth is an inspiring work of art because it reminds us that catastrophes clear sometimes the way for drawing a line under the past and start over in a completely different fashion, reinventing ourselves by acquiring new skills or experiences.

## The Nature Time Spiral by Pablo Carlos Budassi

The history of nature from the Big Bang to the present day shown graphically in a spiral with notable events annotated. Every billion years (Ga) is represented by 90 degrees of rotation of the spiral. The last 500 million years are represented in a 90-degree stretch for more detail on our recent history. Some of the events depicted are the emergence of cosmic structures (stars, galaxies, planets, clusters, and other structures), the emergence of the solar system, the Earth and the Moon, important geological events (gases in the atmosphere, great orogenies, glacial periods, etc.), emergence and evolution of living beings (first microbes, plants, animals, fungi), the evolution of hominid species and important events in human evolution.

Poster 50 x 40 cm by Pablo Carlos Budassi. This graphic shows in a spiral a summary of notable events from the Big Bang to the

present day. Every billion years (Ga) is represented in 90 degrees of rotation of the spiral.

# Daily themes with focus on a different artist.

## Day 0: The Big Bang and the Universe by Corina Chirila

 Corina was born in 1986 in Bucharest. In the year 2000, when she was almost 14 years old, animated by her inner desires and passions, she started drawing and painting inspired by Mihai Eminescu's poems.

She commented about this painting on her website, "The other day I worked on painting inspired by the poem Letter 1 of Mihai Eminescu and I took out the poet's head and the candle in which he blows with tired eyelashes leaving only the image of the universe".

Website: https://desenepicturi.com/galerie/

Day 1:   The Blue Pyramid of Mercury by Victor Filippsky

Victor worked for almost his whole life as an artist, but his main passion is fantastic art. He wants to show people that they are the smallest part of the Universe, which we owe our lives to, and to show the worlds that we are unlikely to ever reach, but our imagination allows us to move around them. Victor works currently around the theme Philosophy of Space.

Philosophy of space and time is the branch of philosophy concerned with the character of space and time.

Space is the boundless three-dimensional extent in which objects and events have relative position and direction. Physical space is often conceived in three linear dimensions, although modern physicists usually consider it, with time, to be part of a boundless four-dimensional continuum known as spacetime.

More of his works can be discovered at https://www.facebook.com/victor.filippsky/photo

Day 2: Venus on another planet by Philippe Fargat.

Philippe Farhat is an artist born in Beirut on March 30th, 1986. He is seeing the art as a mirror of our spirit we reflect the reality of life in different ways and forms. He says, "art is the real of the unreal and the taste of life,,, an unlimited word". His subjects recently were about humanity, dreams of the invisible, listening to the sounds of silence, smelling the power of the universe, seeing the unseen like strange places or different humans in another planets. He describes it as "the untouchable pure reality of the universe humanity and life ....detecting the details in that huge darkness and the features in the lights I compose my artworks from this spiritual strange things from many surreal forms in a big contrast of sizes and colors". You can find more of his art at

https://www.instagram.com/farhatphilippe/

## Day 3: The Earth Issue by Natasha Burbury

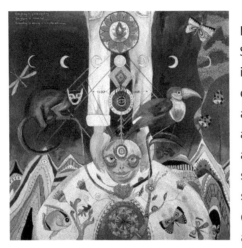

Natasha Burbury a Sydney based fine artist influenced by the trends of the 1960's and 70s and is classing herself as a hallucinatory symbolic artist. She conjures up strange worlds that share her deepest questions about herself and how this is connected her to the natural landscape.

She is presently working on a collection 'One last chance' which asks questions about the effects of temperature variability and its participation with extinction. And what can we really do now to reverse our actions? Using painting as a reflection of her own as well as universal human greed as well as a cry for humans to step up to creating change. Each painting with wildlife intertwined throughout that has been affected by the change in climate.

Website: www.natashaburbury.com

### Day 4: Mars & Beyond by Oskar Krajewski

Oskar OK Krajewski, was born and studied in Poland, is living and working in London UK since 2002, and is Artistic director at Art of OK. His sculptures are made mainly of recycled materials such as unwanted toys, old computer parts and objects used every day.

This image is a picture of an installation he exposed at Mars and Beyond. The vast immersive experience took place across five floors of London's iconic Bargehouse and explored humans now and in the future. The expo examined the science of our planet and presented imaginative alternative futures.

The happening merged two critical themes of the 21st century:

Firstly, the catastrophic rise in global warming, deforestation, animal species extinction and plastic pollution in our oceans; and secondly, the revival of the space race.

Set at the close of the 21st century, 'Mars & Beyond' looked back in time to the year 2020. Creating a perspective through the artistic lens from which to consider solutions for the current state of our planet.

More of his work can be found at the artist's website http://artofok.com/

111

## Day 5: The return of Ceres by Élise Poinsenot

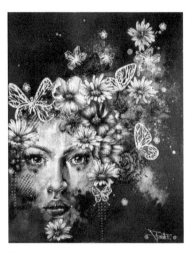

Elise Poinsenot is an art therapist and relational psychopractor, trained in the art therapist movement. She welcomes children, adolescents, adults and seniors in her psychotherapy practice. Art therapy is aimed at all people with psychic suffering, such as depression, anxiety, addictions or loss of meaning, and those wishing to fully create their future.

When Proserpina is with Pluto (her abductor and rapist) the earth is barren and cold, and when she returns to her mother, Ceres pours forth the blessings of spring to welcome her beloved daughter home.

Website: https://www.elisepoinsenot.com/

112

### Day 6: The Eyes of Jupiter by Walter Idema

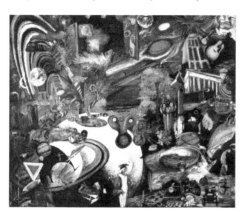

Walter's art features fantastical backgrounds, inhabited by phantasmagorical characters, both human and other, and all layered in translucent, vibrant colors that begs you peel it back and have a peek at what lies just beyond.

There is not much biographical detail available about Walter, apart from the fact that he was orphaned at young age, recently recovered from a serious illness, and is also active as a writer and musician. He lives in Spokane (USA). More works of Walter can be found at https://www.artpal.com/walteridema

Day 7: "Saturn | Adam | Lies Are More Truth" by Adam One.

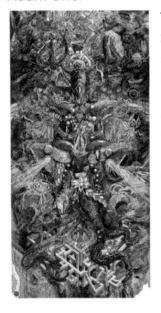

This painting is part of the "Planetary Sublimation" series. The series was started in 2019 and is still currently being explored.

Adam One's work derives from a deep understanding of form and function, and an active interest in the questions of human existence through spiritual evolution. His pieces are born from the subconscious and are extremely chaotic amalgamations of archetypal subjects and stories. Meant to be ever changing and revealing, his pieces beckon one's mind to question the world around, and to look at everything with a new perspective. Philosophically and Spiritually, Adam finds inspiration in the symbols of Theosophy, Cosmogony, Alchemy, Hermeticism and Gnosticism. It is from this groundwork that he constructs his own view of the cosmos. Working ancient concepts into future imaginings.

Website: https://symprez.com/

## Day 8: GAIA AND URANUS by Selim Güventürk

The painter, born in 1951, is based in Ankara and makes his works only with his fingers, without equipment such as brushes and spatula. He transfers themes such as nature, human behavior, mythology, love and freedom to his canvas.

Selim does not have his own website, but has a presence on Facebook at

https://www.facebook.com/people/Selim-G%C3%BCvent%C3%BCrk/1476221491

## Day 9: Neptune's Wrath by Felipe Posada.

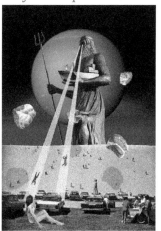

Felipe Posada is a Brooklyn NYC based visual artist, designer and creative director. My Surreal Collage work is influenced by subjects which had an impact in me when I was growing up. Some of those subjects I have continued to explore as I became an adult. My curiosity about Metaphysics, parallel realities, etc. all of that combined with my passion for combining images with a sense of aesthetic and rhythm to create compositions reflecting alternate forms of reality. I believe that images and symbols, if used

correctly, have the power to work directly in the collective unconscious of men. And that is where I wan to leave my imprint.

Website: https://theinvisiblerealm.com/info

## Day 10: REINSTATE PLUTO! By Phil Clarke

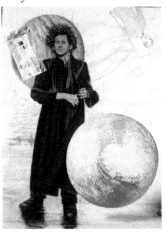

Artist Statement: In this picture, we look at a man alone in the Universe. He is striding forward with purpose, a shaman, a man of the cloth perhaps. But no, looking closer, we see that it is Keith Richards, legendary guitarist and performer with the Rolling Stones.

Despite his bad boy image, Keith is a deep thinker. He has seen the latest images of Pluto from the New Horizons space probe, and he wants to know why Pluto has a heart clearly visible on its round surface, but is still not allowed to be a planet. Keith respects the latest science, but he's thinking 'Couldn't our scientists, just this once, prove they have a heart too, and Reinstate Pluto?'..... I agree with Keith on this one.

Australian artist Phil Clarke (born in 1958) uses Surrealism, Pop Art and Media Images to portray Modern Life. He combines Nature and Technology in a poetic vision which explores themes of Environmental Challenge, Coral Bleaching, Endangered Species, Social Justice, Loss Of Habitat, Renewable Energy and Common Sense.

Website: http://artistphilclarke.com.au/

116

Day 11: CHARON , by Chumakov-Orleansky
Vladimir.

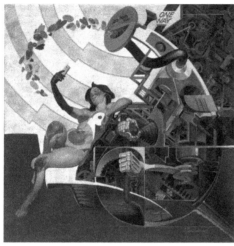

This artist was born in 1962 in Moscow, where he still lives and works. Charon, the carrier of the dead, normally receives his fee at the end of the journey by retrieving a coin placed in the mouth of the traveler.

With this painting the artist implies that we all died long time ago in our phones and our gadgets, and that the electronical Charon is already transporting us over the river Styx.

Website: http://www.vladymyr.ru/

117

## Day 12: Eris by Carne Griffiths

Carne Griffiths is an artist whose work explores human, geometric and floral forms, in a combination of both literal and abstract translation and in response to images and situations encountered in everyday life.

While working with several unusual mediums such as brandy, vodka, and whiskey, it is tea that has become carne Griffiths' trademark in the art world. tea gives his work the warm color palette and rich texture that it is known for.

Website: https://www.carnegriffiths.com/

118

## Day 13: Wanderers: Astrology Of The Nine. A music album by SPECTRAL LORE and MARE COGNITUM.

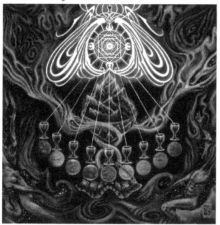

Cover design by Elijah Tamu

Based in Athens (Greece), these veterans from countless successful releases including a seminal split album ("Sol", 2013) that cemented their friendship and earned them unconditioned esteem and love from the atmospheric black metal aficionados, SPECTRAL LORE's sole member Ayloss and Jacob Buczarski from MARE COGNITUM join forces once again for another mystical trip through the stars. Monumental and daring in its length and scope, "Wanderers: Astrology Of The Nine" is a thematic journey through our solar system, illustrating and anthropomorphizing it into mythology which parallels our own humanity with the science of these mysterious formations.

Artist statement: *"Inspired by Gustav Holst's Planets suite, we continue the exploration we began many years ago with 'Sol',"* explain the artists; *"we traverse outwards from the sun to each planet, weaving fables through a synthesis of their distinct physical features and a mythical personhood representing these features. While we wish to capture the awe of the raw, natural beauty of our cosmic surroundings, we have also created our own cosmically inspired lore with each planet as our muse,"* say Ayloss and Buczarski;" *therefore, each track is a narrative which represents our admiration for each cosmic entity: the psychic*

119

*manifestations that were conjured through our own wonder of the majestic planetary system we call home."*

Graced with a wondrous cover painting by the inimitable Elijah Tamu, "Wanderers: Astrology Of The Nine" is nothing but a never ending quest for mankind's cosmic origins, a celestial and philosophical observation on the notes of MARE COGNITUM and SPECTRAL LORE's music, perfectly in the balance between progressive yet furious black metal, and moments of ecstatic, melodic beauty.

released March 13, 2020 on

https://spectrallore.bandcamp.com/album/wanderers-astrology-of-the-nine

### Comment by Langdon Hickman on

https://www.invisibleoranges.com/spectral-lore-mare-cognitum-wanderers-review/

There is a surface parallel to Holst's suite The Planets, but the similarities feel more like loose inspiration rather than a pure adaptation. For one thing, Holst's suite is only seven movements long, omitting both Earth and Pluto (though these would later be added by later composers performing updated versions of the suite). For another, the order of Holst's suite is arrhythmic, moving from Mars toward the Sun until it reaches Mercury, at which point it spontaneously jumps to Jupiter, reversing course afterwards. In fairness, Spectral Lore and Mare Cognitum provide an equally strange order rather dissimilar to the conventional heliocentric ordering. For a standard record of non-thematically linked songs, such questions of order would not even bear mentioning, but here where the album is explicitly a meditation

on the symbolic and astrological values of each of the nine planets and implicitly acting in a superset with their previous collaborative LP featuring similar explorations of the sun, the shift in planetary order is a puzzling one.

Thankfully, the reasoning is obvious on first blush when listening to the record. Regardless of the firm and real naturalist order of the planets, the order presented on Wanderers: Astrology of the Nine reads better. The way that the bright triumphalism of "Mercury (The Virtuous)" leads into the strident and intense militarism of "Mars (The Warrior)" feels sublime, bridging perfectly between a standard medieval contrapuntal complexity in the prog black metal of Spectral Lore into the singularly most ferocious and overtly metallic we have ever seen from Mare Cognitum. Likewise, the egress from "Mars (The Warrior)" back toward "Venus (The Princess)" seems to track with a deepening appellation to a mystic ideal, each progressive song shirking just a little bit more of the earthly material world for meditations on some essence beyond it. This prepares for the passage spanning "Jupiter (The Giant)" to "Neptune (The Mystic)" which seems to symbolically chart the figure of Jupiter as a Jehovah-like figure and Saturn as a Satanic imposer, mediated by the unifying mystic of Neptune. "Uranus (The Fallen)," then, is the fall; Pluto is rendered a gatekeeper, the last remnant of the known before embarking out into the terminal darkness and silence of deep space.

It deliberately invokes, provokes, evokes grand spiritual themes and images. Projects like this are risky, prone to falling on their face and coming across as goofy and ostentatious over-wrought cringe-fests rather than the sincere and potent symbolic meditations they seek to be. Spectral Lore and Mare Cognitum, though, are resolutely sharp writers, avoiding cliched and

hackneyed passages that would turn an album like this into a bad parody of progressive music.

Due to the large number of similarly grandiose concept records that have fallen flat on their face, not to mention spiritualist-oriented extreme metal groups from black metal and beyond who have turned writing explicitly spiritual music into something almost automatically assumed to be dorky and thin, it's hard to describe what's being attempted here without fear of putting off certain people who just want their black metal to be firm, powerful, direct, and free of pretension. But that's precisely the thing: pretension is, by definition, a pretense of something that isn't achieved. But they do achieve it here; despite how absurd and lofty the idea sounds on paper, Spectral Lore and Mare Cognitum nail it.

Each of the planets seems to work in pairs. Mercury and Mars are, as mentioned before, the sharpest and purely black metal. Earth and Venus are soft and rich and intensely euphoric. Jupiter and Saturn are the most excessively epic pairing, with each song feeling structurally much closer to the groups' work on Sol, where each of the meatier songs felt like it could have been split into numerous tracks and released as a satisfactory EP. Neptune and Uranus are profoundly melancholic and depressive, atmospheric affairs. Pluto, meanwhile, is the requisite collaborative piece, this time split into two tracks. The first is a ten-plus-minute dark ambient piece, one speckled with the same fine-grain detail work that makes Spectral Lore ambient tracks such an auditory treat, while the second is a roaring and intense black metal piece. The opening line of the second act of Pluto even begins with the lyrics "Sol's domain ends," lending a bit more credence to the connection between the two records.

122

# Time in Modern Art (Essay)

Time is one of the most common commodities of any artistic work. Yet it is also one of the least comprehended ingredients. Art exists in time as well as space. Time implies change and movement; movement implies the passage of time. Movement and time, whether actual or an illusion, are crucial elements in art although we may not be aware of it. An artwork may incorporate actual motion; that is, the artwork itself moves in some way. Or it may incorporate the illusion of, or implied movement.For those who´re interested in knowing more about the phenomenon Time in Art, I can recommend my essay.

Print length 117 pages
Language English
The Kindle version is available for free for people with a Kindle Unlimited subscription.
The kindle version purchase cost is $ 2.99 (ASIN: B09K43W17R) and the print version costs $ 19.99 (ISBN 9781737783220) .

The cover image consists of a readaptation of Dali´s painting "The Perseverance of Memory".

# Curiosities Cabinet

*The Lady in Red and Her Cryptomathician in Wonderland (London, 2016)*

*The Becoming of an Artist at The Chadwick Gallery*

*The Shape of Time was an exhibition of remarkable artworks dating from 1800 to the present day. Borrowed from some of the most important museums and private collections across the world, they were placed within the rooms of the Picture Gallery in dialogue with our own historical objects and artists, as steppingstones to lead us from the point at which our own collections end to the point at which we stand today. Visitors were invited to look simultaneously backwards and forwards between objects made many centuries years apart, either of which has the potential to alter our experience of the other. In the spirit of George Kubler's groundbreaking 1962 book of the same name (The Shape of Time), the pairings sought to reveal the flow of time and space and the evolution of ideas and images across centuries and cultures, and to suggest a view of art history as a reservoir of ideas drawn from repeatedly over time.*

*Peter Paul Rubens' portrait of Helena Fourment next to a 2021s
nude by Shaharee Vyaas at an exposition in the Kunsthistorisches
Museum; Maria Lassnig Stiftung*

' "Nereid", from 2019 by Shaharee Vyaas, and Frans Hals' "Portrait of Cornelia Vooght," in the exhibition "Rendezvous with Frans Hals."

*Crossroads (painting) by Shaharee Vyaas (2019) and the Hero's Journey (Lamp) by Sarah Schönfeld (2014), Private collection.*

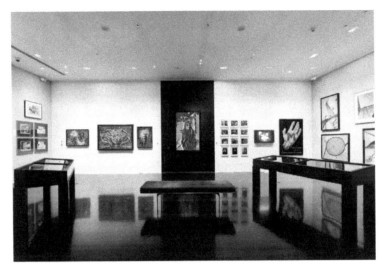

*Latest exposition at The Faculty*

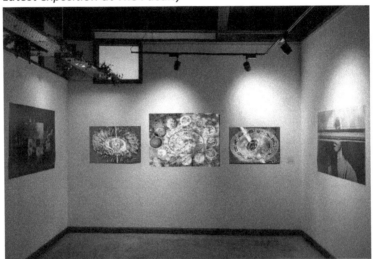

*RightNow Studios is the brainchild of Ryan Blackwell & Nastassia Winge. After a hugely successful inaugural exhibition at Left Bank Leeds in March, having staged an online project looking specifically at collage RightNow Studios staged their second exhibition at The Gallery at 164. ALCHEMY was an immersive*

*experience concocted from a selection of the most investigative,*
*unique, and challenging artists in the field.*

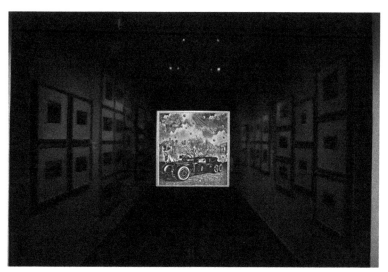

*The Joyful Entry of Omicron at Ronald S. Lauder's Neue Galerie*
*New York*

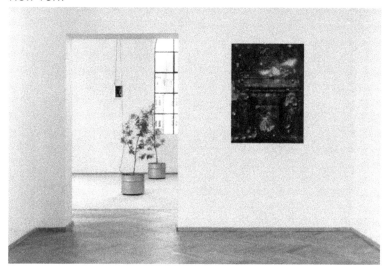

*Evolution at Kunsthal Charlottenborg, 2021. Photo by David Stjernholm. Courtesy of Kamel Mennour, Paris/London, Blum & Poe, Los Angeles/New York/Tokyo.*

*No-Man´s-Land at Artspace 8, a contemporary art gallery that is one of the most unique large event venues in Chicago*

*Amazing Parasites at the Kunsten Museum of Modern Art in Aalborg next to Jens Jaaning´s "Take the Money and Run".*

*Assimilation at the White Cube Bermondsey*

*Lost at the White Cube*

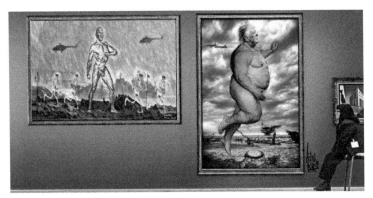

*Two Best Friends in one installation*

# Pricelist

My pricing follows a two-track approach: on one hand you have the original works that aim at the institutional and private art collectors that insist upon a certain degree of exclusivity. These works are priced following the amount of time, expertise, and material that was required to achieve the result.

To make the works accessible for a wider public, open canvas and paper prints are offered at 3.5 times their production costs. That is comparable to the pricing of a dinner in a common family restaurant where the cook calculates the price of a menu by multiplying the purchase price of the meal's ingredients by 3.5, eventually increased with a 10 % service fee. Remember that also artists need to eat!

## Original works

**for sale at date of publication (March 21, 2022. An updated stand can be found at the Saatchi Website https://www.saatchiart.com/shaharee ):**

Assimilation, 60 W x 60 H x 0.6 D in, $35,567
A Cosmology of Civilization, 48 W x 38 H x 0.6 D in, $19,243
Cybernaut, 30 W x 40 H x 0.6 D in, $13,345
Evolution: Entrance or Exit? 32 W x 40 H x 0.6 D in, $13,800
The Final Solution, 24 W x 32 H x 0.6 D in, $8,589
The Hatching of Chaos, 36 W x 24 H x 0.6 D in, $9,765
Pilgrimage to the House of Wisdom, 30 W x 20 H x 0.6 D in, $6,228
The Zone (5-panel installation), 80 W x 80 H x 0.6 D in, $65,321

## Canvas Prints

**for all the works that I have produced.**

Order at https://www.saatchiart.com/shaharee following the budget, format, or size that suites you the best. The only restriction is that prints are only made available in the aspect ratio that suits best the originals.

| Print Size | Aspect Ratio | Pixel Size | Price |
|---|---|---|---|
| 12 x 16 | 3:4 | 1800 x 2400 | $95 |
| 14 x 21 | 2:3 | 2100 x 3150 | $129 |
| 16 x 16 | 1:1 | 2400 x 2400 | $125 |
| 16 x 20 | 4:5 | 2400 x 3000 | $120 |
| 16 x 24 | 2:3 | 2400 x 3600 | $139 |
| 20 x 30 | 2:3 | 3000 x 4500 | $159 |
| 24 x 24 | 1:1 | 3600 x 3600 | $160 |
| 24 x 32 | 3:4 | 3600 x 4800 | $190 |
| 24 x 36 | 2:3 | 3600 x 5400 | $199 |
| 30 x 30 | 1:1 | 4500 x 4500 | $230 |
| 30 x 40 | 3:4 | 4500 x 6000 | $325 |
| 30 x 45 | 2:3 | 4500 x 6750 | $309 |

## Fine Art Paper

Order at https://www.saatchiart.com/shaharee following the budget, format, or size that suites you the best. The only restriction is that prints are only made available in the aspect ratio that suits best the originals.

| Print Size | Aspect Ratio | Pixel Size | Price |
|---|---|---|---|
| 6 x 12 | 1:2 | 900 x 1800 | $40 |
| 8 x 10 | 4:5 | 1200 x 1500 | $40 |
| 8 x 12 | 2:3 | 1200 x 1800 | $40 |
| 9 x 12 | 3:4 | 1350 x 1800 | $40 |
| 10 x 10 | 1:1 | 1500 x 1500 | $40 |
| 12 x 15 | 4:5 | 1800 x 2250 | $70 |
| 12 x 24 | 1:2 | 1800 x 3600 | $70 |
| 15 x 20 | 3:4 | 2250 x 3000 | $70 |
| 16 x 16 | 1:1 | 2400 x 2400 | $70 |
| 16 x 24 | 2:3 | 2400 x 3600 | $85 |
| 20 x 25 | 4:5 | 3000 x 3750 | $120 |
| 20 x 40 | 1:2 | 3000 x 6000 | $120 |
| 24 x 24 | 1:1 | 3600 x 3600 | $120 |
| 24 x 30 | 4:5 | 3600 x 4500 | $180 |
| 24 x 32 | 3:4 | 3600 x 4800 | $120 |
| 24 x 36 | 2:3 | 3600 x 5400 | $140 |
| 24 x 48 | 1:2 | 3600 x 7200 | $200 |
| 30 x 40 | 3:4 | 4500 x 6000 | $200 |
| 32 x 40 | 4:5 | 4800 x 6000 | $200 |
| 32 x 48 | 2:3 | 4800 x 7200 | $220 |
| 34 x 34 | 1:1 | 5100 x 5100 | $200 |
| 38 x 48 | 4:5 | 5700 x 7200 | $240 |

Lightning Source UK Ltd.
Milton Keynes UK
UKHW050843080522
402591UK00010B/26